HAUNTED
ALABAMA
BATTLEFIELDS

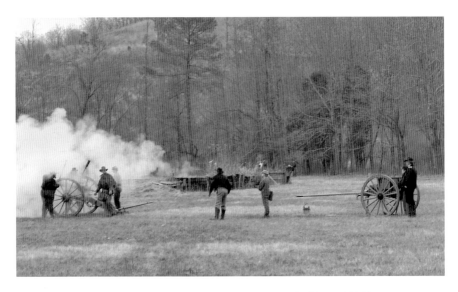

Confederate and Union reenactors portraying the scene at the Siege of Bridgeport.

HAUNTED ALABAMA BATTLEFIELDS

DALE LANGELLA

HAUNTED
America

Published by Haunted America
A Division of The History Press
Charleston, SC 29403
www.historypress.net

Cover image by Noah Bourdeu.

First published 2013
Second printing 2014

Manufactured in the United States

ISBN 978.1.60949.916.7

Library of Congress Cataloging-in-Publication Data

Langella, Dale.
Haunted Alabama battlefields / Dale Langella.
pages cm
Includes bibliographical references.
ISBN 978-1-60949-916-7 (paperback)
1. Ghosts--Alabama--Anecdotes. 2. Haunted places--Alabama--Anecdotes. 3.
Battlefields--Alabama--Anecdotes. 4. Parapsychology--Alabama--Anecdotes. 5.
Alabama--History--Civil War, 1861-1865--Battlefields--Anecdotes. 6. United States-
-History--Civil War, 1861-1865--Battlefields--Anecdotes. 7. Alabama--History--Civil
War, 1861-1865--Campaigns--Anecdotes. 8. United States--History--Civil War,
1861-1865--Campaigns--Anecdotes. 9. Alabama--Social life and customs--Anecdotes. 10.
Alabama--Biography--Anecdotes. I. Title.
BF1472.U6L3645 2013
133.1'22--dc23
2013039036

I dedicate this book to my two children, Cameron and Caitlyn, as well as to my beloved sister, Linda Laliberte Lussier, who passed away during the writing of this book. She was only fifty-two years old. She fought a very hard, five-year battle against ovarian cancer, which metastasized to brain, lung and liver cancer as well. Linda endured things that I could never even dream of, but regardless of her sickness and afflictions, she always remained very happy and high-spirited. She was a proud supporter of my life's work within the paranormal field and always encouraged me to continue with my work and passion. Her passing was a very difficult time in my life. She meant the world to me, and she will be missed dearly. For all her support and belief in me, I dedicate this book to her so that her legacy of love, her kindness and the support that she gave me in her lifetime will live on forever. Life is truly a gift that should always be cherished.

CONTENTS

PREFACE

Say…whether peace is best preserved by giving energy to the government or information to the people. This last is the most certain and the most legitimate engine of government. Educate and inform the whole mass of people. Enable them to see that it is their interest to preserve peace and order, and they will preserve them. And it requires no very high degree of education to convince them of this. They are the only sure reliance for the preservation of our liberty.
—*Thomas Jefferson*

As I read that profound statement from probably one of the most influential persons in history, I thought about the irony regarding what I had just learned in the making of this book. Everyone wants freedom; we will fight for freedom, and we will die for our freedom. We learn lessons from our wrongdoings or through the mistakes of our history. We strive to make things better for one another, and some people even reason that this is the reason our history is so important. They argue that we should never make the same mistakes twice and should take those lessons that we have learned and use them to improve our lives and the lives of others around us. Supposing that we were lucky enough to have had children to whom we can hand our freedoms, we know that these future generations will eventually be in command of our governments. With that thought in mind, this book was written with the intent of sharing the history and stories of the folks in Alabama, their families, their ancestors and the remaining unheard ghosts that seem to be trying to communicate that we have seen days that we should

never see again. They beg us to tell the stories of the atrocities committed and to never again allow this to take place on our soil.

As I walked around the encampment at the Bridgeport Reenactment and began to watch the maneuvers portrayed in the battle, Glenn Hill, a reenactor and curator for the Bridgeport Museum, approached me because he knew that I was doing research for this book. He was dressed in Civil War attire because he was portraying a soldier, and you could see his passion for what he was doing. I was literally halted in my tracks as he pulled me aside and spoke the most profound statement to me. He asked, "What was the most important battle in the Civil War?" Well, being caught off guard, I was honestly perplexed, so I thought for a moment and answered, "Well, I guess that would be Gettysburg, right?" He said, "No, think about this for just one minute." Then there was a brief moment of silence. He looked directly at me, and with complete sincerity radiating from his soul, he continued, "The biggest battle for any soldier in any war was the one that he died in. That was *his* biggest battle."

Stunned at such a thoughtful statement, I looked around at the reenactment and all the folks involved in the remaking of this scene and began to embrace the real meaning of the event. I found myself in a state of contemplation and became choked up after hearing these words. I realized that everyone talks about the Civil War, the horror, the destruction, the sides they chose, the lessons and so forth, but to actually put yourself in their shoes for a brief moment and truly imagine or attempt to feel what it was like to be involved in this terror is a whole new, eye-opening experience. It stirred a certain spirit inside me, enlightening me that I needed to tell these stories to "the masses of people," as well as the future generations of children as they grow up and become able to read these stories.

I needed to tell these stories not only from the perspective of history, or from stories of folks who lived well, but also from the side of spirits that seem to want their voices to still be heard. Are they asking for us to avoid division in our nation? Are they saying, "Don't ever let this happen again"? Are they pleading for no one else to ever have to suffer or die because of war? Do they want justice? Are they still searching for their families? Do they want someone, anyone, to know where they have died and where they are buried? Were they ever honored for their service? Were they ever even acknowledged for the loss of their lives? There are so many questions that still remained unanswered.

I have always considered myself an extreme supporter of our military troops, our country and our Constitution, but many of the stories that I

Union Civil War reenactor at the Battle of Selma. *Courtesy of the Library of Congress.*

came across in the process of making this book left me with one thought in my head: the death, violence, wounds, destruction, agony, cruelty and fighting are never as important as peace. Nevertheless, the reality is that these tragic wars happened, and they brought about extreme pain, grief, wounded soldiers, death, agony, desperation, annihilation, devastation, division among families and friends, tragedy and some of the most gruesome and cruel manifestations of human behavior and accounts ever recorded in history.

These communing ghosts still walk about battlefields, buildings and the surrounding areas of war sites. If you ask anyone about the Battle of Gettysburg, they will most likely tell you a ghost story to accompany the history that happened there. Most people think that these ghosts are probably the same souls who perished in their particular battles. Some paranormal researchers and supporters seem to think that maybe they are just energy impressions, like a recording of the tragic event that continues to play over and over again, like a record player that's stuck on its track or like a loop in time. They believe that the imprints from the tragedy are somehow just stuck

there. Some believe that maybe these ghosts are not fully aware that they are dead and continue to live their lives as they were accustomed to living. We might even find some people, like Father Eric, the Roman Catholic priest I spoke with who believes that some spirits are just stuck here and not quite ready to cross over—for whatever reason, they are not ready, perhaps due to a trauma. He reasoned that they might be unable to accept their deaths or find their way on the other side. Some people even think that it's possible that our dimension overlays another dimension, and because there is no concept of time in the spirit world, they reason that we could be seeing this past, as a reality now, as it is presently happening in the spiritual dimension.

Some paranormal researchers claim that there is no sense of time in the spirit world like we know it. They say that time does not exist, although clocks do. Yet you will find others who feel that the horrific energy from the battles is trapped there, leading to the attraction of ghosts. Are there energy signatures from articles used in the wars, such as muskets, Minié balls and cannons, that still hold on to the energy from the tragedy? Were the items that were used in the battles or carried by a soldier so personal to them that they are still lingering or hanging around the article? Or perhaps is it possible that they are trying to find their belongings?

The one question that we can answer about these battlefields is that the ghosts are not all Confederate or Union soldiers who were killed in these battles. There are many other testimonials of experiences by reenactors and townsfolk—personal experiences of being touched, phantom sounds, disembodied voices, reports of conversations when no one is there, music playing, visions and electronic voice phenomenon (EVP) evidence that supports the existence of different ghosts making their appearances, such as slaves, women, drummer boys, American Indians, Spaniards, children and more.

In many places across the country, these wars were fought in hometowns. The town's homes, barns, churches, slave quarters and land were used as fortresses, hospitals, drilling areas, camps, hospice centers, headquarters and battlefields. Many people experienced the complete ruination of their lives as the armies, infantries, cavalries and regiments infiltrated their homes, took their livestock, captured their horses and set up camp there. It would be reasonable to say that a woman who spends her entire life setting up her home and raising her family there might want to remain there to keep an eye on the property, overlook things or remain there so that no one ever takes her property or her family away from her again. Maybe she has so much empathy in her soul that she

feels she needs to continue to nurse agony-stricken, wounded soldiers who were begging for her to help them.

For those who claim that ghosts are not real or that they are all demons pretending to be someone, such as a family member, all I can say is that from a faithful standpoint, there are many biblical passages that reference ghosts, spirits, demons and angels as different individual entities. Biblical scripture is clear about the fact that ghosts exist. It is not for me to judge or convince you about whether you believe or don't believe in scripture or ghosts; I'm merely sharing the reality of it as I know it from a paranormal researcher's perspective. I have learned much through my research over the years. I don't intend to make you a believer, and I don't intend to prove anything to you if you're a skeptic. I only intend to share these stories and then let you decide for yourself what you choose to believe. Longtime paranormal research has theorized that ghosts, spirits and/or souls represent a form of energy. This is the scientific reasoning behind the use of electromagnetic field (EMF) meters.

From my personal perspective, I can't imagine why a Union soldier might just miraculously appear and walk across a field, never even taking notice of you as you stare in astonishment or point at him in amazement, but then his existence is classified as a demon. If someone observes an apparition of a Confederate soldier who runs right past him or her as if he were still engaged in battle—and never once does the soldier even acknowledge the witness's existence—this sparks a truly astounding spiritual experience to the newly bewildered believer. I would think that if these spirits were all demons, they would be more likely to attempt to have an unseen, direct interaction with a person in order to bring misery, terror and hopelessness to their life. At least, this is what I know through my paranormal research and my faith about how demons work. Coming from a paranormal researcher's frame of mind, demons wouldn't just be taking a stroll right in front of your eyes, as if they were acting out an event that has transpired in the past. I personally think that they have better things to do with their time, like helping to do their part to inspire division, destruction among families, terror, addictions, homicides and much more.

I've worked in this field for many years and have been around the block a few times, so to speak, and in the course of that, I've seen many things that were both completely benevolent and malevolent. Since most people don't really understand the whole concept of the spirit world around us, they automatically assume that everything should be the worst-case scenario, and that's just not the case. I have helped many people deal with just regular

hauntings, whether residual or intelligent, and found that some clients even reasoned that they had a demonic haunting just because of their religious upbringing. We have found that spirits have many different reasons for why they linger about. Some spirits can be bad and some good. I always tell people that the majority of spirits that linger about were people once too. Truly bad cases are very rare.

I'm not going to sugarcoat this and say that everything is good because they are not all good. It's just a fact that if they were not-so-nice people in life, they may remain not-so-nice people in death. But more often than not, we find that the ones that are not so good sometimes have issues, such as maybe guilt for what they have done or even a problem that they feel they need to resolve before they can move on from this earthly plane into the spiritual dimension. Some may even fear judgment after they realize that their consciousness still lives after death. I always tell everyone that my position from a faithful standpoint is that if we have free will on earth—why wouldn't we have free will in death as well? If these spirits feel the need to linger about for whatever reason, then who are we to say otherwise? Do we really have all the answers? Is everything all-inclusive? Having a firm belief is much different than having all the answers. I think that when it's our time to go, we will then finally and completely understand.

Meanwhile, we perform research, maintain our beliefs and apply what we do know. From a religious perspective, the apostle Paul taught that when death comes to the physical or flesh body, the spiritual (etheric) body called the soul is released to live in another dimension. Most people call this other dimension heaven. The important thing to remember is that the soul or spirit is living and breathing, and its being lives in another dimension called the spirit world. This other dimension is not above or below the earth but rather is congruent or intermeshed with our own physical world. However, the spirit world exists on a higher frequency than most people's physical senses can detect. It's like when a dog can hear the frequency of a dog whistle, but we stand there wondering why we cannot. I believe that when we pass, heaven is there and presented to us; however, I do not believe it is forced on us. I believe that God's love is always around us telling us that when we are ready, we can move forward.

If the spirits have a message that they feel so strongly about, such as wanting the living to take notice to the effects of war or maybe wanting the love of their life (say, their wife) to have their wedding ring because they were a soldier killed in battle and can never return, or even possibly that they felt they died too young and just can't accept it, we must remember that

these spirits and souls were people once too. We must strive to maintain a certain level of compassion for whatever it is that they are going through that is keeping them here. People dedicate many memorial funds, gravestones, scholarships and more to acknowledge the lives of our loved ones. This memorial process helps with closure on both ends, but what about those souls or spirits that have no means of closure? Could this be one of the main reasons why hauntings occur?

As we take into account the casualty, wound and disease statistics of the battles, one could reason why there would be so much activity at these battle locations. At least 618,000 Americans died in the Civil War. Some experts believe that the toll possibly even reached 700,000. The price in blood for the Union army was casualties totaling 360,222. Their losses, by best estimate, were 110,070 deaths due to battlefield losses and 250,152 deaths due to wounds and disease. The Confederates' price in blood, which is known less accurately, was approximately 258,000. Because of missing records, especially in the state of Alabama, these are the leading experts' best estimates. Confederate battle deaths ranged at about 94,000, and

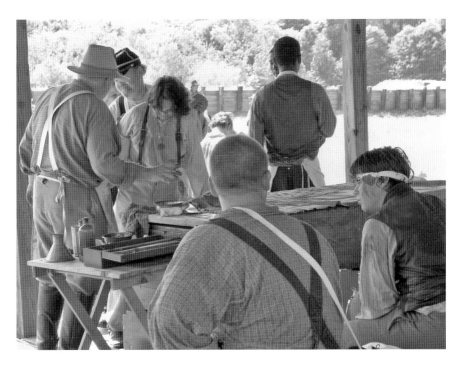

Civil War wounded soldiers receiving medical treatment during a Civil War battlefield reenactment.

deaths due to wounds and disease were approximately 164,000. For every 1,000 Federals engaged in battle, 112 were wounded, and for every 1,000 Confederates, 150 were injured.

Because of inferior medical services and the lack of readily available medical supplies, mortality rates were greater among the Confederate wounded. Medical conditions of the war were severe, as well as horrific. Soldiers underwent surgeries, procedures and amputations without anesthesia, antibiotics, pain medication or even hydrating fluids. The expression "biting the bullet" came about because surgeons would give a soldier a bullet to place in his mouth while they were amputating his arms or legs off. About 15 percent of soldiers died from disease, 10 percent from battle. Although Alabama had few well-equipped hospitals, it had many women who volunteered to nurse the sick and wounded. Soldiers were poorly equipped, especially after 1863, and often resorted to pillaging the dead for boots, belts, canteens, blankets, hats, shirts and pants. The Union army also listed death tolls for those who perished in prisons or from drowning, murders, suicides, accidental deaths, sunstroke, military executions and executions after capture by the enemy, as well as others unclassified. There were also not just Union and Confederate losses in these battles. There were also many thousands of uncounted slaves that were never acknowledged on the army's registries who worked with Confederate troops.

The service of Confederate slaves was involuntary, and about ten thousand slaves escaped and eventually joined the Union army. They were responsible for taking care of horses, equipment, the cooking, the laundry, supplies, building defense mechanisms, repairing railroads and engaging in battle, and they even helped in field hospitals. Alabama soldiers fought in hundreds of battles throughout the Civil War in many states. In the famed battle of the "Alabama Brigade," losses totaled 781 casualties. The emotions were high, the trauma was massive and there were so many deaths of families' loved ones—many of whom were never laid to rest in proper graves. The atrocities committed to the bodies of fallen soldiers are almost incomprehensible. Some soldiers were thrown into ravines, while others were abandoned on the battlefield and left to just rot away. Even yet, other soldiers were deserted, leaving them as a grand meal for turkey vultures or coyotes to feast on. We would be blinded to think that these anguished, tortured and distressed souls and/or family members are even capable of resting in peace. To think that would be just utter nonsense.

The American Civil War in Alabama was significant because the war pitted Unionists against Secessionists. The war ended slavery and

encouraged industrialization. Many Alabamians chose to identify themselves as Southerners rather than Americans at the time. In Mobile, citizens called Lincoln's election "a virtual overthrow of the Constitution and the equal rights of the States" and demanded that Alabama "withdraw from the Federal Union without any further delay." With Governor A.B. Moore in charge, on January 7, 1861, delegates from the state who were elected (without any votes by women or the 45 percent of Alabamians who were enslaved) voted to declare Alabama's immediate independence from the United States, announcing that Alabama had withdrawn its star from the U.S. flag and was now flying it alone.

Those present understood that soon Alabama would add its star to a new confederacy of states, three of which had already withdrawn from the Union. The convention resulted in votes of sixty-one to thirty-nine in favor of secession. Many voted against the measure because they either opposed secession altogether or because they were in favor of cooperation with other states. In Montgomery about one month later, delegates from six other seceded states met to create the new government of the Confederate States of America. Alabama quickly offered Montgomery to serve as the new government's capital, and on February 18, 1861, Jefferson Davis arrived to take the oath as president of the Confederate States of America.

The occupation of North Alabama remained an important Union objective throughout the war because of its transportation routes. Many Northern politicians, including President Lincoln, also believed that they could undermine the Confederacy from within because of the distribution of votes during the 1861 convention, in which many delegates of Alabama opposed secession. Alabama also later sent troops to the Union, most conspicuously the First Alabama Union Cavalry, which eventually escorted General William Tecumseh Sherman on his famous "March to the Sea."

Because many women were limited to options available to them, there was really no work for them. Many people struggled because they lost everything, and many children went to orphanages after husbands died in the war. Many residents of Alabama today still live and operate businesses in old plantation homes, mansions, slave quarters, forts, stagecoach inns and other houses, all of which tell stories of the ghosts that once inhabited the property. We must remember that thousands of children, fathers and husbands went off to war from these locations. Sometimes the buildings served as hiding places or hospitals to help with the wounded, such as the hidden attic that housed wounded soldiers at Octagon Hall in Franklin, Kentucky, or a basement hospital like at Sweetwater Mansion in Florence, Alabama.

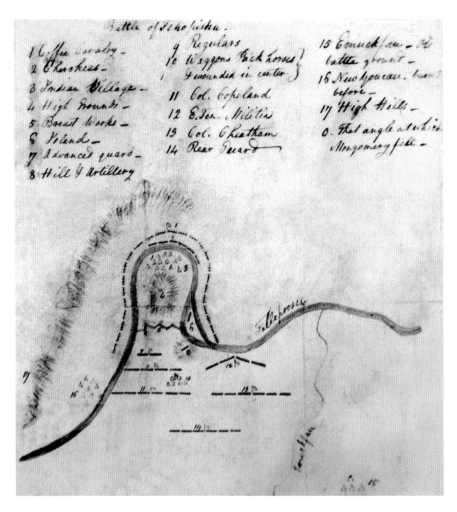

Battle of Tohopiskaa.

1 Coffee Cavalry -
2 Cherokees -
3 Indian Village -
4 High Mounds -
5 Breast Works -
6 Island -
7 Advanced guard -
8 Hill & Artillery

9 Regulars
10 Waggons Pack Horses }
 4 wounded in center }
11 Col. Copeland
12 E. Ten. Militia
13 Col. Cheatham
14 Rear Guard

15 Emuckfau - old
 battle ground -
16 New Youcau. burnt
 before -
17 High Hills -
0. That angle at which
 Montgomery fell -

A Horseshoe Bend battlefield map, personally drawn by General Andrew Jackson, which notes details of the battle during the Indian Creek War of 1813–14.

On a different note, a Civil War among the Creek Indians resulted in many casualties as well. The first fights between Red Stick Creek Indians and the Americans took place on July 21, 1813. On August 30, 1813, the Red Sticks, led by Red Eagle William Weatherford, attacked Fort Mims. The Red Sticks captured the fort by surprise and carried out a massacre, killing men, women and children. They spared only the black slaves, whom they captured. The Indians killed nearly five hundred at the fort. On March 27, 1814, General Andrew Jackson's Tennessee militia, aided by the Thirty-ninth U.S. Infantry

Regiment, as well as Cherokee and Lower Creek warriors, crushed the Red Sticks at the Battle of Horseshoe Bend. The Red Sticks were defeated, and about three thousand American Indians died in the war. There is an old saying in the South: "The Good Lord willing and the Creeks don't rise." This phrase was a common expression and a flashback to the days of the Creek Indian War of 1813–14, particularly the Red Stick attack on Fort Mims, Alabama. The saying has nothing to do with running streams.

The spirits still ask for us to understand what happened to them. Although we cannot demand appearances on command, they will often interact with us or try to get messages across to the living. They honor us with their presence, trying to communicate the details of the tragedies and atrocities committed against them. Sometimes they just want us to understand their emotional pain, so that we will never again let these tragedies happen to other human beings. It is important to tell these stories exactly how they happened so that people may understand why some of these poor, agonized souls cannot truly rest in peace. As recalled by a wounded soldier, "We were only provided two crackers to last us for three days. These were days and nights of the most fearful and causeless suffering, hardships and deprivation that I ever endured in my life." It would be impossible to tell these stories without some of the significant details that made them so cruel, horrific and tragic. These are the collected tales of spirits that still want to be heard, shared by families, reenactors and eyewitnesses. This book is intended to honor all those who fought and died for what they believed in.

ACKNOWLEDGEMENTS

There is no such thing as an author producing a book of this magnitude without the help of many historians, researchers and other professionals. I have many people to thank for their help in the making of this book. This is not an all-inclusive list of the folks who helped, as that would probably be a whole book in itself, but there are some wonderful people who went above and beyond providing outstanding assistance during the making of this project.

First I would like to thank my commissioning editor at The History Press, Chad Rhoad, for his help and patience with me as I embarked on this endeavor to add a new chapter to my life as a novice author. I would also like to thank Ryan Finn and all the other people who worked on this book at The History Press as well. They made this book shine in a way that I could never have imagined. I owe an equal debt of gratitude to my Alabama Paranormal Association (APA) team members, especially Gini Brown, research director of the Alabama Paranormal Association. Gini traveled the entire state with me while enduring hot, sticky and humid weather conditions—at times camping in mosquito- and spider-infested locations to get the research information that we needed for this book. I am deeply grateful for her friendship and time, as well as for her hours of effort in research work that helped make this book possible. Patrick Fairbanks, public relations director for the APA team, was also extremely valuable in his contributions concerning deep sources of information. I would like to thank other members of our Alabama Paranormal Association team for their patience and contributions to the book, which included gathering information, visiting locations for research

purposes and helping me recover data due to a crashed computer system. I am also very grateful that I didn't have to make a tour through the state alone. They include Courtney Colvin, Ryan Pierce, Jack Brown, Kim Darnell, Rhonda Watkins, Niki Lane, Shawnda Tiernan, Jeana Copp, Joe Copp, Casey Brown, Timothy Pearl and Monica Allstatt. I would also like to thank my niece, Nicole Bonchuk, for her support.

Of all of the museum and historical site visits, one of my truly favorite experiences was at the Crooked Creek Civil War Museum in Cullman, due entirely to Fred Wise. I also enjoyed visiting and spending time talking with Glenn Hill, the Bridgeport Depot Museum curator. They both have my deepest gratitude for their help on this project. Glenn was an extremely vital source of information. I would also like to thank some other folks who were generous with their information and help, including Judge David Breland of the Historic Old State Bank in Decatur; John Allison at the Morgan Creek County Archives; Linda Derry of the Old Cahawba Archaeological Society; Jacque Reeves, curator of the Historic Donnell House in Athens; Officer Simmons, deputy sheriff, of the Elkmont Police Department, who was kind enough to escort us to Sulphur Creek Trestle because we got lost in our travels; several of the park rangers at Historic Blakeley National Park; rangers from Fort Gaines; reporters (including Melissa Brown, Andrew Perez, Kelley Kazek, Robert Hudson and many others from all over the state) who helped us obtain valuable information from community residents; the director of Horseshoe Bend National Military Park; the Alabama Historical Commission; the GHOST Paranormal Team; the CAPI Paranormal Team; and Beyond Sight Paranormal. A special thank-you also goes out to Lance Carraway at CSX Transportation for helping me obtain photos on the railway.

I want to say a special thank-you to my husband, Dave, and my two children, Cameron and Caitlyn, for their support and hours of patience while I traveled the state gathering information for this book and the countless hours dedicated to writing it.

A quick thank-you as well to all my readers for believing in me, supporting me and encouraging me. The book also wouldn't be complete without acknowledging God for allowing this to book to happen. I thank both Jesus and God for all their inspiration and faith in me as I continue to walk and trust in the paths they have chosen for my life.

One final thank-you goes out to all those who were willing, ready and available to tell their stories. It is my hope that this book may help remind humanity about the true meaning of life through the tragic stories of these tortured souls' sufferings.

THE SIEGE OF BRIDGEPORT

Although Alabama wasn't the hardest-hit state in the Civil War, many people don't really know about all the different battles that took place on our own soil. The Battle of Shiloh in Tennessee has earned the title "Bloodiest Battle of the Civil War," and many other states had "grand" battles that took place, such as at Gettysburg. Although the battles in Alabama were not particularly famous battles in history, we cannot discount the conflict that took place in the state. The devastation made an impact on the families in this state, just as with any other battle that took place during the time of war. There were deaths, tragedies, destruction, devastation and lost love ones who were never found.

We begin our haunted stories with one of my favorite battle locations in Alabama, the Siege of Bridgeport. More than one conflict was fought at and near Bridgeport, although none could truly be called a battle due to the small number of troops involved. Thus, the primary conflict fought here was called a siege. Because of its location on both a rail line and the Tennessee River, the town of Bridgeport was a strategic site during the war.

The American Civil War with its division of Northern and Southern states over states' rights and slavery soon brought the conflict to Bridgeport. President Lincoln wanted to protect east Tennessee because it was very pro-Union, and citizens felt that they were under siege. Union generals Don Carlos Buell and Ormsby Mitchel got the idea that if they could occupy the railroad lines running from Nashville to Chattanooga, they would be able to get control of east Tennessee. They were also trying to get control of

the Memphis–Charleston line. The Siege of Bridgeport was an unsuccessful attempt because the bridge was burned by Confederate troops. The siege took place on April 29, 1862, and thirty-four Confederates were killed, while many others were wounded. Union troops, under the command of General Ormsby M. Mitchel, who was headquartered in Huntsville, attacked Confederate troops under command of General Danville Leadbetter.

The Confederate troops were camped on the hill at Bridgeport overlooking the river and bridge. Historic Battery Hill was five hundred yards of high ground running from the west end to East Bridge. The hill was named Battery Hill because of the batteries that were located on the land to defend the bridge. Leadbetter had a fort (just a big house, really) for security, with Confederates of 450 young men and boys. They were ordered to guard the railroad bridge going to Chattanooga. Union supplies coming in from Nashville were transferred by railroad to steamboats for transport up the Tennessee River to Chattanooga, where they supplied Union general William T. Sherman's troops during the Atlanta Campaign. The Confederates were trying to stop this action of supplying the Union forces with artillery and supplies. Bridgeport would continue to play a vital role during the first years of the war as Union and Confederate troops would capture and recapture the town.

In April 1862, Union general Ormsby Mitchel had the impression that there were 5,000 Confederate soldiers in Bridgeport protecting the town, so he decided to bring about 1,200 men with him from Fort Harker in Stevenson, Alabama, which was composed of four regiments of infantry, cavalry and artillery to prepare for the battle. But the attack became a siege because there were about 1,100 to 1,200 Union soldiers fighting against 450 Confederate soldiers. A report from Brigadier General Leadbetter on May 5, 1862, regarding the siege of April 29, 1862, noted that his army consisted of 450 newly raised regiments of the Thirty-ninth and Forty-third Georgia, with 150 cavalry employed only as scouts.

Leadbetter reported, "The infantry was at post on the heights leaving a rear guard of fifty men near the bridge end and on either side of it, covered by musketry breastworks. Two iron six-pounders were placed on either side of the bridge but were withdrawn as soon as the Union army advanced. The Union could advance on both the front and the flanks and cut off the troops from the bridge and the riverbank. Even on the island or on the east shore of the river, they would have occupied the low ground." In General Leadbetter's report, he continued to state that he had informed his commanding officer that his army couldn't protect both sides of the bridge and railroad very well

because the bridge was too high off the ground, too far from the banks of the river and spanned well over a mile and a quarter across the river. The Confederates did not have enough army men to cover the riverbanks and the fort, as well as guard the whole length of the bridge, which included protecting both sides of the east end and the west end of the bridge.

The defense was very difficult for such a small force. The Confederate troops would not have been able to protect the West Bridge against surprise or destruction. They had .58-caliber black powder, artillery pieces that used standard twelve-pound cartridges, twelve-pound rifles and two old, outdated iron six-pounders of Kain's battery that had been placed in the only area available on the east bank. The cannons eventually had to be abandoned under the Union army's fire and heat of the burning bridge. The Thirty-third Ohio Union troops pushed eastward along the line of the railroad, crossing over roads that were so bad that the artillery was often dragged by hand. Confederate pickets were encountered about three miles from Bridgeport. After half an hour's fighting, during which the casualties were slight, the Thirty-third Ohio fell back, but because the Confederates had no means of crossing the stream, the Union army was not pursued.

As General Leadbetter crossed the bridge to see if everything was prepared for blowing up a portion of the bridge, the Union army opened fire with rifled guns and a howitzer. At this time, he observed the rear guard crossing the bridge, but ten or twelve scouts near the southwest end of the bridge refused to move. While waiting for his hesitating scouts to cross, Leadbetter paused for a reasonable amount of time before he ordered the fuse to be shortened and fired. It was only when he saw that the troops were not going to move that he advanced with the order to fire the charge of two hundred pounds of powder in one mass. Leadbetter carried out the instructions with the assistance of Captain Kain (artillery division) and Lieutenant Margraves (sappers and miners).

The bridge was soon aflame, impassible to the Union army; however, the bridge was not destroyed completely. There were actually two bridges, the East Bridge and West Bridge, which extended in one straight line with a railroad embankment between them. Because the combination of the two bridges attached together was so large, only a portion of the bridge was burned. At that point, the east end of the railroad bridge had been damaged by the Confederate army, leaving the west end and the middle of the bridge still intact. The Confederates were guarding the bridge, fighting with the advancing Union troops from the railway, and blew it up so the Union couldn't use it to supply the Army of Cumberland at Lookout Mountain.

During the burning of the bridge, only two Confederate soldiers were wounded by shell fragments as a result of the Union forces.

Meanwhile, as this activity was taking place, Union troops were advancing by the roadway as well. General Mitchel came upon a road leading into Bridgeport, and the Union army was secretively advancing on the fort, toward the encampment. The destructive action on the bridge by the Confederates was simultaneously taking place as Union general Mitchel was arriving in Bridgeport by road with his troops from Fort Harker in Stevenson, Alabama. Fort Harker, only about nine miles away, was an earthen redoubt, 150 feet square, with walls that were 14 feet high, surrounded by an 8-foot-deep dry ditch. It overlooked Crow Creek and contained seven cannon platforms, a bomb-proof powder magazine, a drawbridge entrance and an eight-sided wooden blockhouse at its center. After following the road, General Mitchel reached the Confederate fortifications on the bank of the Tennessee River in Bridgeport. He covertly advanced, discovering much of the Confederate force eating supper and lounging around without concern.

Many of the Confederate soldiers fled without even taking their arms; however, the main body seized their guns and tried to make a stand. The attack swept through them, scattering the soldiers and causing death and destruction. The Union troops fixed bayonets and swept back down the hillside, but before they reached the bottom of the hill, the whole Confederate force broke up and fled. Captain Loomis of the Confederate army then placed his battery in position to take on the Union forces stationed on the railroad. The battery formed its line of battle and came up within three hundred yards of the Union troops. A fire of canister was aimed at the Confederates and created another panic. Both cavalry and infantry threw down their weapons and fled. Since the Confederates were severely outnumbered and the position there was futile, the Confederate army was ordered to evacuate. General Leadbetter felt that the Union army could occupy any part of the area that it wanted based on the terrain and location of the roads near the bank of the river.

The ensuing battle resulted in the deaths of several men from both sides, as well as the destruction of the railroad's drawbridge by the Confederates. Although the whole bridge was not completely destroyed and only the east end was blown up at that moment, it was definitely impassible and could not be used by the Union army to transport supplies to Lookout Mountain. Leadbetter decided to retire to Chattanooga and keep the Union forces under observation while hoping for reinforcements. In early May 1862, just several days after the siege on April 29th, Union General Mitchel withdrew

Confederate soldiers resting at their encampment during the Siege of Bridgeport Reenactment.

from Bridgeport. But before he left, he ordered his Union troops to destroy and burn the rest of the railroad bridge. On that Saturday morning, the Union army set fire to the west end of the Bridge in Bridgeport, and it was then completely destroyed. Thus, the Battle of Bridgeport was considered a loss for the Union army because it couldn't supply Chattanooga and the Army of Cumberland at Lookout Mountain by railway.

The Union army fort at Battery Hill came under command of Colonel Prince Felix Salm-Salm of the Sixty-eighth New York Infantry, while Union forces under command of General William S. Rosecrans would soon occupy Bridgeport. Union forces would hold it for the remainder of the war. The fort on Battery Hill along with one across the river and two blockhouses guarded the railroad bridges at Bridgeport against Confederate attacks during the last two years of the war. The Union troops would rebuild Confederate forts and construct new ones to defend Bridgeport. In addition, the town would be the location of a Union field hospital and a military cemetery.

With the Union now controlling the bridge, Bridgeport became the major shipping center for troops and supplies going to General William T. Sherman's

infamous "March to the Sea." The shipping route from Bridgeport to Chattanooga became known as the famous "Cracker Line" because rations supplying the Union soldiers heading toward Lookout Valley in Tennessee were composed mostly of hardtack and dried beef. Union major general William Rosecrans forgot to order supply rations to be sent from his supply depot in Stevenson, Alabama, and the troops were down to about a half ration per day, surviving on what they had left. The men nearest Brown's Ferry got the dried beef, leaving only hardtack for the remaining soldiers. Hardtack was simply a cracker that was as hard as a rock. "Cracker" was the nickname for hardtack.

In the latter part of the war, Bridgeport was the site of a shipyard that built gunboats and transports for the Union army. Both the USS *Chattanooga* and the USS *Bridgeport* were built there. The railroad drawbridge at Bridgeport was burned one additional time during the Civil War by General Bragg's Confederate troops, with both bridges being rebuilt by the Union army along with the railroad between Nashville and Chattanooga. Major

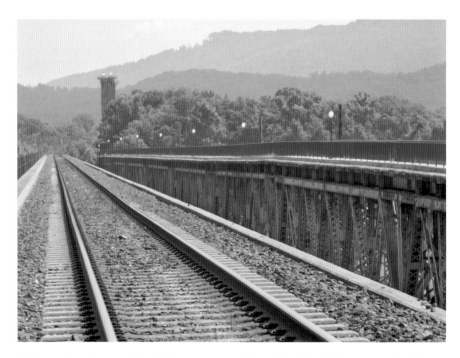

Bridgeport's railroad walking bridge (to the right) is the West End Bridge that was rebuilt on the columns of the original bridge, which was blown up during the Civil War. The iron columns that appear in the back of the photo are part of the East Drawbridge, which connects the whole railway line together. This is the site of much unexplained activity.

General Philip H. Sheridan's Union Division constructed the railroad trestle and a temporary pontoon bridge in late August 1863 as part of Rosecrans's advance prior to Chickamauga.

Bridgeport's location on the railroad and Tennessee River led to it becoming a major supply base for the Union army and Union general William T. Sherman's Atlanta Campaign. The Union army would continue to occupy Bridgeport until well after the end of the war in 1865. Union general Mitchell reported as follows to the secretary of war: "The campaign is ended, and I now occupy Huntsville in perfect security, while all of Alabama north of the Tennessee River floats no flag but that of the Union."

If you consider what we have now and then think about those boys running around without much protective clothing; barefooted; encountering poison ivy, thick brush, spiders such as black widows and brown recluses, bugs and mosquitoes; with slim rations of food (and the fact that some of them hadn't eaten in days), the conditions they endured were both miserable and terrible, not to mention they were frightened for their lives as well.

The Ghostly Soldier on the Farm

I started my broad expedition on a very large, wonderful farm belonging to Mr. McGraw, located in Bridgeport, Alabama, about two miles from Battery Hill. I thought, what better way to get the information for this book than to attend the town's annual reenactment? Mr. McGraw proudly hosts the annual Siege of Bridgeport Reenactment on his farm every year. The farm has been owned by the Williams family for more than 175 years. As a matter of fact, the farm was given to the family by a land patent from Andrew Jackson on September 4, 1834, well before the Civil War. The reenactment teaches children what life was like during war time—and that there wasn't anything "civil" about it.

During the interview with Mr. McGraw, I learned so much about the battle that took place in Bridgeport and on his own land. Mr. McGraw even allowed me to visit his family cemetery, where he knew at least six Confederate soldiers had been buried. Mr. McGraw was such a wonderful and hospitable person, and I found that he loved to talk about the battle. I also found out during our lengthy interview that the Confederate and Union troops had indeed battled directly on his land. His family's farm had been the site of a skirmish when the cavalry from General Sheridan's

army came through the ridges of the two distinct mountains adjacent to and on his property. Sheridan's men were part of the forces that captured Missionary Ridge (near Chattanooga) in 1863. We talked for quite a while, standing among the furious reenactment cannon and gunfire sounds, which penetrated every molecule of my body. I was so intrigued to learn about everything that truly happened there in Bridgeport.

In our conversation, Mr. McGraw mentioned that in previous years, a reenactor observer had caught an apparition of a ghostly soldier with a video camera on the field at his reenactment site. As I walked around the encampments, taking photos and visiting with the reenactors, many of them had wonderful stories to tell about their experiences. I found out that they regularly travel to many battlefields to perform at reenactments because they are extremely passionate about it. Many of the reenactors had ancestors in the war. They travel from state to state and battle to battle acting out the scenes as they once transpired. I have to say that I was greeted very warmly. These folks are some of the most wonderful people you could ever meet.

Although I heard many stories, one reenactor told me about a tale of a ghostly vision that he had observed during a reenactment at Bridgeport. He said that he thought he saw a whole line of soldiers on the ridge as if he was seeing the images of the battle itself. He said he then turned to his friend, who was sitting with him at the encampment, and asked him if he could see what he was seeing. His friend just looked at him dumbfounded, never seeing anything. He told his friend that he could see some men walking and other men riding their horses over the terrain and through the trees. As he tried to focus better, he then said that they just disappeared.

Was this a vision of a ghostly past that still resonates at Mr. McGraw's farm? Was the soldier caught on video a resident ghost from Civil War times? Was he just a Confederate soldier guarding his territory and this farm for the Southern cause? Were these ghosts reliving their actions on the farm as if the battle were still taking place? Could these soldiers possibly be some of the Confederate soldiers who are buried on Mr. McGraw's property in the family graveyard, and are they now attached to the land for centuries to come? Mr. McGraw was not so quick to say whether he does or doesn't believe in paranormal occurrences, but he said that it's all up to the person as to what you choose to believe.

THE UNION SOLDIER RIDING HIS HORSE

One of the most haunted areas in Bridgeport is the area around the railroad and pontoon bridge, which is now a walking bridge nested next to the railroad tracks. Some of the stone remains from the old homes that were standing during the Civil War have been made into benches along the paths of the walking bridge. Residents have stated that many Minié balls have washed

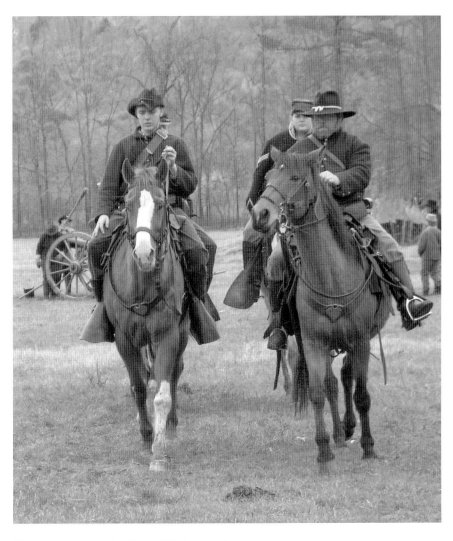

Union reenactors at the Siege of Bridgeport Reenactment.

up in the ditch along the railroad tracks whenever it rains. During the war and after the takeover of Union forces, many Union soldiers were ordered to patrol the area at and near the railroad bridge, including the riverbanks. A resident who lives on the ridge property just below Battery Hill, which overlooks and connects to the railroad, shared a story that happened many years ago. One evening, the resident was resting in her living room, and curious to see why the community's resident dog was barking, she looked out the front picture window of her home. To her amazement, she witnessed a full-body apparition of a Union soldier riding his horse across the front lawn of her property.

Stunned and confused, she wondered if what she was looking at was real. As she continued to watch to see what he was doing, she said that he rode his horse the whole length of her front lawn. He appeared to have the standard blue Union uniform on, with a gun as a weapon attached to his side. It seemed almost as if he was just patrolling the area in defense of the enemy. She claimed that she could even hear the hoof beats of the horse as it made minor *thud* sounds when crossing the lawn. He then just suddenly disappeared into the night without a trace.

She has not spoken of this incident to many people, but she still believes that what she saw that night was the ghost of a Union soldier riding his horse. She felt that he was probably continuing to patrol the railroad bridge to keep it from falling back into Confederate hands. It was not uncommon for soldiers of either side to be found patrolling the area of the bridge, railroad and river during the Civil War era. They were ordered to patrol and guard the bridge at access points on both the east and west ends of the bridge. They were also prepared to do battle if necessary. Other people who have lived at this residence have also claimed to see this soldier, as well as odd-looking lights that seemed very unusual. Is this ghost a Union soldier who took pride in his duty guarding the bridge from Confederate hands? Does he think he is still working his post? Was he guarding the riverfront so they could not dismount with their cavalry at ports along the riverbank? Could this have been General Buell, General Mitchel or even a soldier in charge of the operations at the bridge? Is this the soldier whose body was found in the river? No one can know for sure who this soldier was, but it's apparent that he seems to think that he still needs to remain there guarding the railroad.

The Soldier at the Cannon

Sitting on Battery Hill is a reproduction cannon that overlooks the Bridgeport Depot, which was placed there to commemorate the Siege of Bridgeport. Another interesting story comes from a young woman and her friend who just wanted to play ghost hunter like you see on television. She stated that she was out just having some fun and doing some recordings with a friend. She came to us with a story of the soldier she encountered at the cannon on Battery Hill. It was about 11:00 p.m., and she was hanging around the cannon doing recordings. She said that her brand-new batteries began to drain on her recorder and camera while she was doing an EVP recording session. She was asking aloud if the cannon belonged to anyone who fought during the Siege of Bridgeport. She said that she felt a cold sensation run right through her. Her EMF meter also began to light up, and she said that she heard a whisper on the side of her to the right.

At that moment, she felt a significant tap on the shoulder. Startled by this experience, she said that she wanted to run. As her friend calmed her down and she gathered her composure, they decided to listen to their recording. To their amazement, there was a voice response on the recorder. The voice stated he was a young boy who fought in the Civil War. Although the gun was not actually involved in the conflict at Bridgeport, could it be that this was the

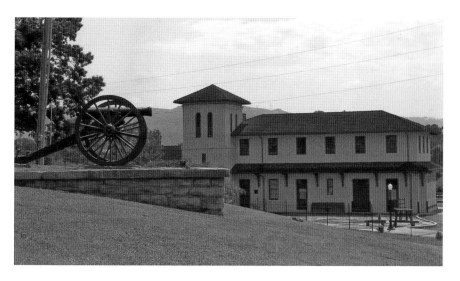

Memorial cannon honoring the Siege of Bridgeport. The cannon is seen here overlooking the Historical Bridgeport Railroad Museum.

ghost of a young boy that operated similar cannons at another location in the Civil War? Is he still guarding these cannons as a reminder of his battle, no matter how far he is away from his home? Was he a soldier that fired the guns in Bridgeport's battles? Was he trying to let the young girls know that he is still there, ready to fight and unleash whatever was necessary to defend his life?

The Woman in the Kitchen

I contacted local resident Katie Creek of Bridgeport, who lives near the historic site of the railroad. She is very knowledgeable about the Siege of Bridgeport, as her family has lived in the area for many years. She gave me some background on the battery that patrolled Battery Hill, among other soldiers who patrolled the area. She told us that we must remember that many soldiers had family members who lived in their town (where they were often enlisted). Sometimes the family would follow the soldiers and work as nurses, cooks, attendants or helpers. They had wives, children, brothers, sisters, mothers, fathers, nieces, nephews and other family besides.

Being a believer in the paranormal herself, she noted an experience that she had in her home. She had many stories of different incidents to tell, but the most intriguing was the story of the old-fashioned, middle-aged woman whom Katie saw in her kitchen. She stated that she felt like someone was just watching her, so she turned around and saw an older woman manifested as a full-body apparition. She said that she wore a long white dress and was definitely not from this era. Katie did not feel threatened in any way. She believes that the woman could possibly have been the wife of a soldier or the owner of the home that stood by the railroad during the Civil War. If this ghostly woman's home was directly affected during the war, maybe she is still looking for her home? Maybe she relates to Katie as being a homemaker?

The home on the land directly next to the railroad has been destroyed and is no longer there, but when it was on the property, it was located just about one hundred feet from Katie's home. Katie believes that the ghostly woman is related to the war, and for some reason, she is still overseeing that land. Katie also believes that this ghostly woman lived in the home during the Civil War. Since the home was located only about seventy-five feet from the destroyed railroad bridge, is it possible that her home was burned during the battle? Could she have been in direct firing lines, and could she have been taken prisoner? Is this why she still lingers about?

THE CANNON IN THE RIVER

The Bridgeport Depot Museum curator, Glenn Hill, shared a story with me that an iron six-pounder cannon was found in the river not very far from the bridge. Many local historians and residents in Bridgeport have heard many stories about the Confederate army cannon being dumped in the river. However, there seems to be much controversy regarding how the cannon actually got there. Could it be possible that a voice from the grave may actually be able to clear up this tale? The main story depicts that the Confederate army abandoned its cannons because it was ordered to retreat and head toward Chattanooga. The common folklore circulating among the community in Bridgeport claims that the Confederate soldiers did not want the Union army to capture their cannon and use it against them, so the Confederate soldiers pushed the cannon down Battery Hill, plunging it into the river and rendering it unusable.

However, there is another story that comes from a local historian; he believes that the cannon was actually supported on the deck of one of the ships that ran through the river. At the railroad museum in Bridgeport, local historian Glenn Hill showed me a peculiar photo of a cannon that

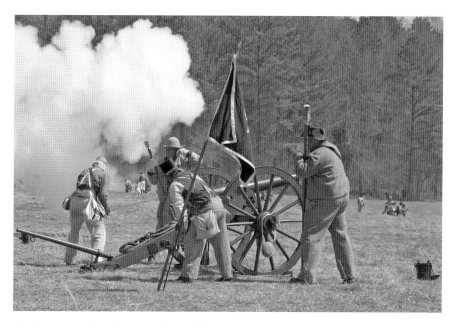

Confederate artillery fire at the Siege of Bridgeport. *Courtesy of the Library of Congress.*

was on the front deck of a boat that was docked at a port on the right side of the river in Bridgeport. Glenn believes that it is entirely possible that the cannon somehow rolled off the riverboat, most probably due to an accident involved with the ship, and it just fell into the river because of the weight of the cannon. It was on wheels and would not have been easily stopped if it rolled off the bow.

A twist to this particular story comes from a local paranormal team that heard about an abandoned Civil War–era home in Bridgeport. The team was anxious to investigate the site. The old abandoned home sat directly on the bank of the river located just below Battery Hill. The team members broke out all of their fancy gear, equipment and meters and started asking questions in the hopes of finding the answer to this baffling old story about the cannon in the river. Some members of the team began to feel extremely sad at the location and started to immediately get responses on their equipment. A guest investigator who appeared to be intuitive was with the group that night. She said that she felt strong energy at the location and heard a voice say, "Now you know what we fought for." She said that she also felt the sense of a Confederate soldier walking behind her as she walked the whole trail near the river. At one point on the way back to base, she noted that the soldier appeared right in front of her and touched the lights on her head. She added that he seemed intrigued by the equipment and the headlamps. Could he have thought there were funny lights on the team members' foreheads?

One particular ghost identified himself on the team's equipment as a very young Confederate soldier who had fought under General Leadbetter's orders and died there during the Siege of Bridgeport. The soldier also claimed that the cannon was, in fact, actually rolled down the hill by Confederate soldiers and pushed into the river. However, the bizarre twist to this tale is that it was not because the Confederates wanted to abandon the cannon to keep it from getting into the Union army's hands, but rather because the cannon had malfunctioned after firing. Based on yes and no answers, he stated that it had broken and it was no longer functional.

What is astonishing about this story is that it is very feasible that there could have been something wrong with the cannons because they were over twenty years old, and many of the artillery pieces in the Civil War were known to malfunction if not properly cleaned and loaded correctly. There were many weapon and artillery accidents—guns would blow up in someone's face due to overpacking the black powder or because of improper cleaning of the gun. Is this tale realistic as to what could have truly happened

to the cannon in the river? Does this ghost know something more than we know since he claims he was there while they were engaged in battle? We will never truly know the real answer to this tale, but it surely is interesting to look at it from a different perspective coming from beyond the grave.

THE CONFEDERATES IN THE WOODS

Many of the local teenagers go to the back of the old abandoned house in Bridgeport and set a campfire near the river. There is a rock pit with wooden logs that still bears the marks of a fire burning. As we performed our research for this book in Bridgeport, many of the locals were more than happy to help us obtain information and share their stories. It seems that a small group of local teenage boys found out about our research purposes in Bridgeport, and they hunted us down to share their story. They were more than happy to share their experiences about being near the river at the old abandoned house.

One night, they were about a mile out, at the end of a trail that leads to the river behind the old house. It was very late and not too cold; it was almost a perfect night. There was, however, a chance of rain, so the air was a little humid and thick. They said that they had just lit a campfire and were enjoying stories about their day, as well as the school's football teams and their girlfriends. Since they had just finished walking through high brush to get to the river, they said that they had just finished checking each other for ticks while they were seated on the logs surrounding the pit.

After about an hour and a half of just talking, a sudden breeze came through the area that gave the boys ice-cold chills. Of course, being near the river, they didn't pay much attention to it. It wasn't until one of the boys said that he thought he saw something out of the corner of his eye in the woods that they stood up to take notice of their surroundings. They were worried about the possibility of a wild animal such as a coyote, skunk or deer. Since they didn't really see anything, they kept chatting among themselves while enjoying the moonlit fire. Again, an ice-cold breeze came over them, and they instantly got overwhelmed with sad emotions. They were so intense that they began to shed a few tears. They didn't understand what was happening. This was just a bit too odd of an experience for them to make any sense of it.

They then said that they saw about three Confederate soldiers coming toward them out of the woods carrying arms. They said they felt completely

surrounded. In a state of frenzy, amazement and fear, they put out the fire immediately by frantically kicking sand over it. They left the location as fast as they could. After they left, they all went home fairly freaked out. One of the boys claimed that after he went home, he was in bed and was woken up at about 4:00 a.m. He said that at the end of his bed, he saw a Union soldier in uniform standing there, just looking at him; then he just disappeared. He jumped out of bed, turned on the lights and composed himself but couldn't sleep for the rest of the night. He kept thinking that it was just his imagination because of the experience at the river. He never saw the soldier again, and the boys have never returned to the location.

They believe that what they saw that night at the river were the Confederate soldiers who fought and lost their lives during Bridgeport's conflict. The young boy believes that he may have been followed home by a Union soldier who had participated in the Siege of Bridgeport. They have never doubted the existence of ghosts again. They wanted us to know of their encounter; however, the experience left such an impression on them that they refused to return to the location with us, as they felt too uneasy to go back there. Were these soldiers reaching out to tell a story? Did the Union soldier follow the boy home because he had a southern accent, and he thought he was a Confederate? Were they just guarding the area as if they were still at post? Is this place truly haunted? They say that it's difficult to believe in the existence of ghosts, but after that experience, there is no doubt in the boys' minds that the ghosts of the battle still remain there.

THE BATTLE OF FORT BLAKELY

The last major battle of the Civil War was fought at Fort Blakely hours after the actual war ended with the surrender of General Robert E. Lee hundreds of miles away in Virginia. Blakeley is a small town above the mouth of Blakeley River, about four miles north of Spanish Fort and about twelve miles from Mobile. The town itself was named Blakeley, and the fort became Fort Blakely after the Confederates seized it. The name of the fort actually lost a letter *e* after the Confederates gained control of the garrison. Historic Blakeley State Park is named after the town that was there before the Civil War. The fort and earthworks at this point were under the command of Confederate brigadier general St. John Richardson Liddell.

In the early 1800s, there were about four thousand residents at the town of Blakeley, and at that time, it was actually a bigger town than Mobile. There were two hotels in Blakeley, with one being the Alabama Hotel. There is a legend that Andrew Jackson actually stayed in the Alabama Hotel. The town suffered severe yellow fever epidemics from 1822 to 1824, and everyone moved away, scattering to outlying communities. Mobile did not have the yellow fever epidemic as severe as Blakeley, and that is why Mobile survived and Blakeley did not. The town had everything it needed, including a port on the river that was used for transportation as well as bringing supplies and ships in from the river. The town of Blakeley barely had one hundred people still calling it home by the time the state left the Union. The port was actually used as an evacuation

route for Confederates during the Civil War, but unfortunately, some of the boats had already left, leaving the soldiers to fight or hide.

General William T. Sherman, having completed his march to the sea, wrote to General E.R.S. Canby suggesting that he concentrate his attentions first on Spanish Fort and Fort Blakely on the eastern shore of the bay, opposite the city of Mobile. Mobile's western approaches were heavily defended, and this strategy offered a better chance for success. Canby planned to lead thirty-two men himself from Dauphin Island both by boats and overland up the eastern side of the bay to Spanish Fort. General Frederick Steele was to lead thirteen thousand Union soldiers over a long route from Pensacola, Florida, to attack Fort Blakely from the north. The successful assault on Fort Blakely on April 9, 1865, would be the last major land battle of the Civil War, being fought just six hours after General Robert E. Lee surrendered the Army of Northern Virginia to General Ulysses S. Grant at Appomattox Courthouse.

At Fort Blakely's 3,800 acres, there are old earthen forts, rifle pits, redoubts and battery sites. Union forces launched simultaneous attacks on the Confederates of both Spanish Fort and Blakeley, Alabama. This was in a desperate attempt to force their way into Mobile itself. Federal troops took Spanish Fort after a prolonged siege on April 8, 1865, but the Confederate garrison at Fort Blakely still hung on tenaciously to its breastworks.

After the fall of Spanish Fort, orders were issued to take Fort Blakely by assault. The advance began at 5:25 p.m. on April 9, 1865, but because of the lack of quick communication throughout the states, the battle started six hours after the surrender of General Lee. They did not know that the war had ended. Most of the Confederate camps were well in the rear of the fort, but during downtime, the troops could take rest on the slopes and out of the direct firing line. Out of all of the redoubts in the fortification, Redoubt No. 4 was the strongest structure protecting Fort Blakely. This fort held four field guns, a mortar and a seven-inch rifle cannon that was never actually used due to having an incomplete carriage. The men encamped here were of the First Missouri Brigade. The Confederate cannoneers were from many different states, such as Alabama, Mississippi and Tennessee.

There were many obstructions, such as sharpened wooden stakes, broken trees, brush and wire that were laid out two to three hundred yards in front of the Confederate works to help protect the area. Around the location were Confederate rifle pits about twenty yards apart that would contain an average of five soldiers. The purpose of the Confederate pits was to keep the Union out of the ravine. The soldiers stayed there all day and night

Artillery reenactors engaging Confederate artillery fire at the Siege of Bridgeport. *Courtesy of the Library of Congress.*

with only rations of corn, crackers, water and ammunition. The Fifteenth Massachusetts Battery held an area directly behind the Confederate gun pits that consisted of three twelve-pounder Napoleons. At an area directly adjacent to the Confederate lines were gun pits of Union soldiers that contained about three soldiers per pit. The area behind the Union gun pits consisted of land mines that contained explosive twelve- and twenty-four-pound cannon balls with pressure triggering devices. They were concentrated between the Union rifle pits and their main trench, leaving the Union army men to take caution wherever they walked.

In 1865, siege warfare was pretty simple. It meant one thing: dig. Attackers dug zigzag battle trenches toward the enemy position, dragging artillery behind them. Rifle pits were dug and filled with infantry, who moved between them in connecting trenches. These were called "skirmish lines," and they were moved forward as the siege progressed, allowing more and more troops to become available for battle. It was always dig more, dig deeper and dig faster right up to the enemy while bringing increased firepower. Digging was

a nighttime job. There was little fighting at night during the Civil War, with the exception of patrols and artillery fire. The average soldier fought all day and dug all night while hungry, thirsty, dirty, sleep-deprived, under gunfire and going to the bathroom in some corner of their trench or rifle pit.

The main trench was developed by Moore's Brigade, Andrew's Division, consisting of the 83rd and 114th Ohio, 34th Iowa and the 37th Illinois. This position was adopted due to the area being five hundred yards from the main Confederate line of resistance and within rifled musket range. The Federal camps were arranged about two to five hundred yards to the east, which was far enough to offer protection from shell fire and Minié balls.

The Eighty-third Ohio embarked on March 20 over difficult, swampy roads, northward along the railroad to Stockton, twenty miles from Blakeley, arriving there on the thirty-first, which was their objective point. They had plenty of cattle and sheep but no bread, coffee or salt. They were in good spirits even though they were half famished. They were placed in line of battle. After dark, they moved forward and stacked arms, and then they were told to lie down silently as it was not known just how near they were to the enemy. They were awakened long before daybreak and moved farther to the rear. They wanted to be on the safe side in case they were too close. The black troops were stationed on the extreme right of the Union line.

The Union had excavated 2,767 horizontal yards of rifle pits. The Confederate works were three miles long, with nine redoubts and a gunboat stationed at each end of the line. The breakthrough came when a Union brigade, led by the Eighty-third Ohio Infantry, stormed over the walls of Redoubt No. 4. At that point, the Confederate lines collapsed. The Eighty-third Ohio had three ravines to pass through, and the ravine nearest the garrison works was very deep and long. When the unit advanced about 200 yards, it came to the principal line of Confederate rifle pits, still somewhat occupied. The Confederate sharpshooters' guns were taken from those who surrendered and broke the line. The obstacles of brush and logs made it difficult passage.

Then the ravine began to ascend to high ground in front of the redoubts. The fifty yards between the works were just about impassable. The Eighty-third stooped down to avoid the destructive fire that was being poured into it. However, again, many of the Confederates broke ranks and ran to the woods. Stationed against this weak skirmish line were the First, Third, Fourth and Fifth Missouri Infantry, as well as the First and Third Missouri dismounted cavalry, one of the most famous fighting brigades of the Confederacy, under

the command of Brigadier General Francis Marion Cockrell. These troops stood up with their muskets, but most of the shots went over their mark.

As soon as a passage was opened, Lieutenant Colonel William H. Baldwin gave the order for the regiment to advance again. With their bayonets, the men pried an opening through and then rushed forward, and although they still encountered numerous obstructions, they were soon on the redoubt. A private soldier is said to have been the first over them. Lieutenant Colonel Baldwin was soon on the scene, and he jumped down inside and cried out, "Surrender." It took just eighteen minutes from the time they received the word to go to get inside the fortifications. They captured eight hundred prisoners and some twenty pieces of artillery. But this was not accomplished without blood payment. The regiment lost six killed and twenty-four wounded. The field over which the charge had been made had been planted with many thousand torpedoes—or "subterra shells," as the Confederates termed them—but not one had been stepped on by any men of the Eighty-third regiment. After the battle, the Confederates were compelled to locate, cap and dig up the torpedoes, under a penalty of being marched back and forth until all had been exploded.

Black forces played a major role in the successful Union assault. Nine regiments and three infantry brigades of the United States Colored Troops (USCT) were at the Battle of Blakeley. They gained the inside of the fort and captured more than one thousand men with their commander, General Thomas. General C.C. Andrews's Second Division of the Thirteenth Corps Black Division had charged over torpedoes and through a storm of bullets, and by seven o'clock, the fort was Union property, with prisoners including Confederate generals and gains such as thirty-two pieces of artillery, four thousand stands of small arms, sixteen battle flags and a vast amount of ammunition.

Some Confederates chose to escape to the waters of the Tensaw River and were said by eyewitnesses to have been picked off by rifle fire from the shore. The entanglements past the ditches were also fatal to many. The Federals in the attack on Redoubt No. 4 suffered about 25 deaths and 35 wounded. The Southern troops lost about 12 killed and 20 wounded. About 800 Confederate soldiers from the Blakely fortification were captured in the battle as well as in the woods and swamps. The total loss during the whole battle and assault for the Confederates was about 100 killed, 300 wounded and 3,500 captured. The Union army sustained damage as well, with a reported toll of 116 killed, 655 wounded and 4 missing.

The Ghost of Little Jeffrey

One of the best locations for Civil War preservation and attractions is Historic Blakeley State Park. Redoubt No. 4 on the main battlefield was the major fortification for the Confederates. It took the hit for the biggest part of the battle. According to park rangers, there was a ten-year-old boy named Jeffrey who was accidentally killed at the location. He was not a combatant; he was just a little kid who was hanging around the Confederate soldiers. Because he was just a little boy, they had befriended Jeffrey and given him a Confederate hat to wear. Unfortunately, the Union troops mistook him for a Confederate soldier. The Union troops captured him that day and made him walk out to show them where the land mines were buried. During this maneuver, Jeffrey was accidentally blown up. Many of the rangers and visitors to the park claim to see Jeffrey on the battlefield all the time. He is said to haunt the exterior of Redoubt No. 4. The story further notes that one day, a park ranger was mowing the battlefield lawn near the redoubt and happened to look up. He saw Jeffrey manifest as a full-body apparition. It scared the bejeebers out of him so much that he instantaneously took off on his lawnmower, drove back to the office, dismounted the lawnmower and left it right there. The ranger left the park immediately, and the other park rangers say that he has never returned to the park again.

The Confederate Soldier at Campsite 5

Campsite 5 at Historic Blakeley State Park is a beautiful area with a picnic table, a fire pit and camping conveniences. It is located directly on the battlefield in proximity to the Confederate lines. It is also right on the edge of the massive cemetery. Park rangers and visitors to the park claim that Campsite 5 is haunted by a Confederate soldier.

Many people have claimed to see a Confederate soldier sitting on top of the picnic table early in the morning. The rangers mentioned that they know of at least two or three people who have actually photographed him, but the rangers were unable to get the photos because the campers left before they could inquire about getting copies of the photographs. This camping area would have been the site of 3,050 Confederate troops heading toward Union lines in defense positions. Other people claim to have seen and felt

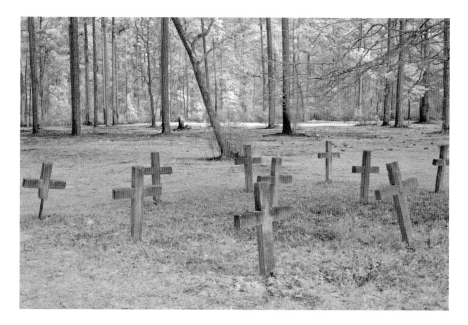

The massive grave markers at Fort Blakely National Historic Park. Fortification ruins at Fort Blakely still appear to hold on to energy from the battle that took place here. Visitors of the park report a considerable amount of spirit activity. *Courtesy of the Library of Congress.*

the presence of a slender Confederate soldier dressed in a gray uniform walking near the graves and toward the campsite. They say that he does not appear to be threatening. One could wonder why he would be just leisurely sitting around, hanging out on a picnic table or taking a stroll. Could he be just continuing to guard his post?

THE UNION SOLDIER AT CAMPSITE 15

Campsite 15 is a wonderful, sheltered camping area, also considered to be a very haunted location at Historic Blakeley State Park. People who have camped at Campsite 15 have told park rangers that they have seen a Union soldier walking around it. This would have been the area located directly at the Union lines and not far away from the Union headquarters. There were thirty-five thousand Union soldiers advancing through this area, heading toward the Confederate strongholds. Maybe this soldier still thinks he is in battle? Could he still just be strolling around, taking a leisurely walk like they

probably did after the fort was taken? Could he be one of the unidentified soldiers buried at Fort Blakely? Park rangers have stated that there are known to be twenty unidentified Confederate soldiers buried near Redoubt No. 4 and another twenty unidentified bodies of both Confederate and Union soldiers buried near Redoubt No. 2. They have also found five additional unknown graves while performing their work throughout the park. Are these graves tragedies of the yellow fever epidemic, or are these soldiers from the battle that took place at the fort? Could one of the unidentified individuals be the little boy named Jeffrey who still haunts historic Fort Blakely? How many other unknown and unidentified soldiers are still buried there at the park? Is it possible that these souls will continue to walk about the battlefield until they are found or until they have closure?

THE BATTLES OF DAY'S GAP, CROOKED CREEK AND HOG MOUNTAIN

When we first met Mr. Fred Wise at the Crooked Creek Civil War Museum, he enthusiastically explained to us that he had a Civil War collection before he bought the land that he resides on now. The Crooked Creek museum, housed in the former Vinemont Stagecoach Inn, contains his private collection of Civil War artifacts. He said that when he bought the property, he was unaware that his land was the site of a very significant running battle in the state of Alabama, Streight's Raid, along with being a repository of bullets, cannonballs and even the remains of several entrenchments near the creek itself. He said that he didn't know any of this until a local resident told him. It was the very ridge where skirmishes transpired and where Union forces attempted to ford the Crooked Creek while running from Confederate cavalry. This was one of several skirmishes that were launched during the raid as a result of a chase begun at the Battle of Day's Gap and continued across Alabama, with Streight's brigade of saddle-sore soldiers on mules.

Union colonel Abel D. Streight, a bookseller at the beginning of the war in Indianapolis, was the commander of the Fifty-first Indiana Infantry in 1863. He thought up an idea of a raid through northern Alabama. Following a major conflict in middle Tennessee, Colonel Streight (with Union loyalist Alabamians as guides) planned to ride through northern Alabama and on into northern Georgia to destroy the rail hub of the Western & Atlantic Railroad, which would have crippled the ability of the Confederates to supply their forces in Tennessee. The raid was not intended as a cavalry raid, as most of Streight's forces were to consist of mounted infantry, with their mounts

Union colonel Abel D. Streight of the Fifty-first Indiana Infantry, commander of the "Lightning Mule Brigade" cavalry raid in 1863 (also known as "Streight's Raid"). *Courtesy of the Library of Congress.*

being used for transportation only. Streight was given command for his raid of a brigade of 1,700 men, which consisted of two companies of the First West Tennessee and First Alabama Cavalry regiments, as well as the Third Ohio, Fifty-first Indiana and Eightieth Illinois Infantry regiments.

On April 10, 1863, Union colonel Streight was loading four regiments of infantry, two companies of cavalry and two mountain howitzers, with all their equipment, arms and ammunition, plus more than seven hundred noisy, cranky, foul-smelling mules onto a small fleet of boats. Signs that the expedition was ill-fated started when most of the men were mounted on very temperamental mules. Riding a mule can be a hard task even for a skilled rider. The mules were nothing but poor, wild and unbroken colts, many of them young, and a large number of them had horse distemper. About forty or fifty were too near dead to travel, so they left them behind, and ten or twelve died before they even started. Some were so wild and unmanageable that it took them all that day and a part of the next to catch and break them before they could move out across the country.

In the mean time, they had sent out several parties to gather more horses and mules. They had been successful in getting about four hundred good horses and mules overall, but along the way, a stampede broke out, and many were lost to the Confederates. The loss of the animals was a heavy blow to Streight's command, detaining them for nearly two days and running down their stock while searching the country to recover them. Nearly all of the animals taken from the country were barefooted, and as the traveling expedition went on, many of them had such sore backs and tender feet that it was impossible to ride them. The men, being unaccustomed to riding, had become so exhausted from fatigue and loss of sleep that it was almost impossible to keep them awake long enough to feed.

Confederates deemed Streight's men the "Jackass Cavalry" and had great fun laughing at them. Union morale among the soldiers suffered severely as a result. Finding the Union soldiers was a fairly easy task for the Confederates during the raid because of the constant braying of the mules. The slow pace of the mules made certain that any Confederate force mounted on horses was going to be much faster. Streight recognized the problem with the mules from the beginning and objected to them prior to the raid. Streight's Brigade headed down the Cumberland and then up the Tennessee River to begin a raid that would be the biggest event since the war began.

Lieutenant General Nathan Bedford Forrest commanded a small force of five hundred cavalry and pursued Streight, who never comprehended that his force outnumbered that of his pursuers by three to one. Colonel Streight's men took a defense stance and managed to resist attack as they continued their march ahead to avoid any further delays caused by the Confederate troops. The Battle at Day's Gap set off a string of skirmishes at Crooked Creek (April 30), Hog Mountain (April 30), Blountsville (May 1), Black Creek/Gadsden (May 2) and Blount's Plantation (May 2).

On April 30, 1863, Confederate lieutenant general Nathan Bedford Forrest caught up with Union colonel Abel Streight's expedition and attacked his rear guard at Day's Gap. The battle lasted about five hours, from 6:00 a.m. on April 30 to about 11:00 a.m., leaving twenty-three Union soldiers dead and Confederate casualties numbering sixty-five. One account, handed down by the family of Confederate soldier Private Williams J. Ledbetter of the Fourth Alabama Cavalry, noted that the limestone rock in the area was so close to the surface that the Confederates could not bury their dead but instead were forced to roll their bodies into a steep ravine before following Streight south.

Colonel Streight crossed through the ford at Crooked Creek and was met by General Forrest's forces at Hog Mountain. Streight's men were about six miles from their first

Lieutenant General Nathan Bedford Forrest, a Confederate army commander during the Civil War who lacked formal military education but had a gift for strategy and war tactics. *Courtesy of the Library of Congress.*

battleground when the Confederates were discovered advancing on their left. Extreme skirmishing was launched at Crooked Creek, which is about ten miles south of Day's Gap. The Confederates pressed the Union's rear so hard that it needed to prepare for battle. Union forces selected a strong position, about one mile south of the crossing of the creek, on a ridge called Hog Mountain. On top of the hill was where Streight placed four cannons—two mountain howitzers and two captured Confederate pieces—to command the valley. The whole force soon became engaged about one hour before dark, and the fighting continued until about 10:00 p.m. at Crooked Creek. From that point on, it was a running battle. A large number of soldiers were killed and wounded on the field. If Streight had ever just turned and fought Forrest head-on, he probably would have won, as he heavily outnumbered the Confederates, but he just kept on riding, occasionally stopping and setting up a battle line. As the fighting began, Streight's men took up a defensive position between a ravine and a swampy area, hoping to prevent their being flanked by the Confederates. Streight determined at once to resume the march.

Forrest and Streight were using the same trails the Indians used. These trails were also used by Davy Crockett and General John Coffee, as well as some 890 Tennessee volunteers, during the Creek Indian War. Overall, the trail used by Forrest and Streight is about 225 miles long. The running battle was also unique in that the Crooked Creek skirmish between Forrest and Streight was fought approximately between 5:00 p.m. and 10:00 p.m., making it the only battle to continue after dark.

These battles were associated with the "Lightning Mule Brigade." The brigade consisted of the Seventy-third Indiana, Fifty-first Indiana, Eightieth Illinois and Third Ohio regiments and First Alabama (Union) Cavalry.

Streight's Raid continued through Alabama until he finally reached his destination at Rome, Georgia, and was forced to surrender his entire command of 1,500 men to Forrest. Although ultimately defeated and his raid rendered unsuccessful, Streight was considered the victor in both of the major fights with Forrest because Forrest lost two of his favorite cannons at the Battle of Day's Gap, both of which were prizes he had personally captured earlier in a conflict in Murfreesboro, Tennessee. According to Streight's account, the ammunition captured with the two cannons was exhausted, and he ordered the howitzers spiked and their carriages burned. Local stories say that the two cannons still remain there, buried in Hog Mountain, as he said they were never recovered.

Streight thought that there was an approximate total of about 15 Union officers and about 130 enlisted men killed and wounded on the journey,

but because he had no way to confirm this, he could not give a completely accurate account. The skirmishes also left many Alabamians dead on both sides of the conflict.

According to Colonel Streight's official report, he noted that owing to the nature of the service they were performing, he was compelled to leave his wounded behind. Colonel Streight provided for them as best he could by leaving them blankets, rations and two of his surgeons to attend them. However, when the Confederates got possession of their hospitals, they robbed both officers and men of their blankets, coats, hats, boots, shoes, rations and money. The medical stores and instruments were taken from the surgeons, and the wounded were left to perish in a nearly naked and starving condition, in some instances many miles from any inhabitants. Several ladies of the country saved many brave soldiers from horrible deaths.

Three Alabama units that fought in the battles of Streight's ill-fated raid were the Fifty-third Alabama Cavalry (also known as the Partisan Rangers, who were attached to the Twenty-ninth Alabama Infantry, CSA); the Fourth Alabama Cavalry, CSA; and the First Alabama Cavalry, USV, which consisted of many North Alabama men who volunteered to serve the Union. The First Alabama Cavalry, the only cavalry unit of the six Alabama regiments, was also the only such unit to contain both black and white soldiers. The First Alabama was chosen to be General Sherman's personal escort on his infamous "March to the Sea." On May 3, Forrest surrounded Streight's exhausted men three miles east of Cedar Bluff, Alabama, and forced them to surrender. Streight's ammunition was worthless, their horses and mules were in desperate condition, his men were overcome with fatigue and loss of sleep and they were completely outnumbered by three to one in the heart of Confederate country. Although Streight was personally opposed to surrendering, he yielded to the unanimous voice of his commanders and at once entered into negotiations with Forrest to obtain the best possible terms he could for his command.

At about noon on May 3, the men of Streight's unit surrendered as prisoners of war and were sent to Libby Prison in Richmond, Virginia. Nearly all of his soldiers were confined as prisoners or died of disease that was the result of long confinement, insufficient food and cruel treatment. Streight remained a prisoner of war until February 9, 1864, when he and some of his men escaped from captivity. Streight's Raid had one very important unintended achievement. It prevented Lieutenant General Nathan Bedford Forrest from participating in an attempt to stop Grierson's Raid, which was occurring at the same time in Mississippi.

UNION AND CONFEDERATE SOLDIERS STILL WALK THE GROUNDS

Since the time that Mr. Fred Wise has owned the property at Crooked Creek, he has allowed visitors to enjoy the grounds as well as the museum. Many visitors have taken an interest in just walking the trails, which travel down to the ford at the creek where the soldiers crossed, fired their weapons from gun pits and tried to avoid the cannon fire from the Confederate army. Occasionally, you will even find campers, such as Boy Scout units that stay the weekend on the battle site. At present, there is signage on the trails that shows visitors exactly where the battle and crossing took place. Many people have experienced ghostly visits of apparitions that seem to appear out of nowhere. Some of the visitors have said that a man will appear right in front of your face within a one-foot distance. Others have said that they have seen a young woman who appears to be from the Civil War era walk the grounds near the bed-and-breakfast area. Still others have offered more detailed accounts, noting that they have been approached by or witnessed Union and Confederate soldiers still walking the grounds.

Some of the accounts say that a Union soldier was noted walking along the front lawn of the location. He was dressed all in Union blue company attire, with a blue hat and weapons by his side. His rank appears to be more of an authoritative position, such as a sergeant. What is most impressive of this account is that there are records of periodic rain in the journals of this battle. They said that the ground was muddy and wet at times. This particular soldier was identified carrying his weapon with the gun barrel pointed down. This would have been usual procedure for soldiers in the rain. They didn't want the rain to get into the barrel of the gun causing rust or even problems with the black powder. It was also less likely to result in an accident if the gun went off.

There are other accounts that note a limping Union soldier approaching people near the ford, asking for help because he was severely wounded. This soldier appears clutching his chest, and they can see a gushing hole there. Could he have been one of the soldiers at the creek who was hit by cannon fire, musket fire or Minié balls? The personal accounts further say that he has blood running down all over him and that they instantaneously feel nausea. They say that the scene unfolds as if he was just recently wounded and seeking help. Is this nausea a symptom of him feeling sick due to the wounds that he had sustained? Is he trying to impress that feeling onto others to get us to pay attention? Do people just feel sick because of seeing this tragic incident unfold before their

Image of an unidentified Union Civil War soldier. *Courtesy of the Library of Congress.*

very eyes? Whatever the reason for this unexplained encounter, shocked visitors are not prepared for this disturbing sight.

Not surprisingly, there is another account of a young soldier dressed in gray Confederate clothing who appears to be just an enlisted soldier. He has appeared near the same location, at the end of the trail near the ford, but just a bit closer to the gun pit. He appears to be walking out of the trail area from where the entrenchments are, holding his abdomen. He is stumbling and struggling to stay upright but cannot due to his wounds. Visitors claim that he has short dark hair and appears to be very thin, tired, weathered and dirty, and his hair is also wet. He seems severely wounded and is covered in blood; he then falls to the ground right in front of people and begins to vomit. Is this poor, wounded, agony-stricken soldier suffering from physical shock due to the injuries he has sustained in battle? Is he throwing up because he knows there is no way he can survive this kind of wound and live? What is going through his mind at that moment? Are these soldiers looking to the living to help them dress their wounds or save their lives? Are they walking around still thinking that they are engaged in battle? Do they even realize that they are no longer in the physical world and have passed on into death? Or are they impressing on us the tragic reality of war?

THE LINE OF SOLDIERS ON THE RIDGE

Crooked Creek was notorious for the Union defense on the ridge. Many Union soldiers stood their guard in a defensive position, with weapons ready, as they were being approached from the rear. The strategy was that they would form a line of soldiers to repel the approaching enemy while allowing the other soldiers in their unit to move forward to continue the journey—hence the phrase "running battle." They would then swap their positions, allowing the next line of soldiers to reach more ground, form their new position and take a stance, forming a new line of defense, with guns drawn. All of this occurred while being fired on by the enemy.

Could this be a reasonable explanation for a photo that had been taken on the ridge at Crooked Creek depicting this formation of a line of soldiers? A local paranormal team out of Florence, Alabama, shared its photographic evidence of a picture taken with an infrared camera system that depicts a line of soldiers located along the ridge of Crooked Creek. They appear in uniform, and there is a line of about ten or more men that are noted along the ridge. Could it be that they are in formation ready to battle? The team members also shared additional photographic evidence that was captured at the location. On the property at the ridge, they captured a light anomaly containing an extremely bright circular orb. The odd part of this particular orb is that it appears to have a face in it and almost looks like an embryo. These photos are proudly displayed in Mr. Wise's Civil War museum. There have also been reports of Union soldiers being seen on the ridge, as well as noises in the distance that people say sound like conversations. Other than the museum at the front of the location, there is nothing but remnants of woods, trees and trails all around. The property remains as it once was back in the days of the war.

THE PHANTOM SOUNDS OF THE GUN PITS

A local Boy Scout troop was camping one weekend at Crooked Creek. There were about ten tents in the camping area set up with all kinds of camping gear surrounding them. The Scout master and a few of the older Scouts joined up with our team to talk to us while we were doing research for this book. They eagerly told us some stories about a colored fog or mist that they had seen near the gun pit entrenchments. They also claimed that

they had seen little bright lights that would just appear and disappear. Since I'm such a skeptic at times, I often find myself trying to debunk things, so I immediately asked them if they thought that the lights that they had seen were just lightning bugs. The place was rampant with insects, animals and of course, beautiful lightning bugs, so I just assumed that they were mistaking the lights for something naturally occurring in nature.

They told me that they knew the difference between a lightning bug and what they saw. They said the lights were a great deal larger, some occurring in different colors such as blue, white and light green. They also said that they just hovered for a while and then swiftly sped off in a horizontal direction before disappearing. They said that there is no way they were lightning bugs. They had a round shape to them and were transparent in nature. They also said that they hovered up and down slightly, in a pattern that would not be typical for any insect or bug. Since they had been there for a whole weekend, they also said that they found some relics of gun shells during the day that they excitedly gave to Mr. Wise. They further stated that throughout the night, they would hear gunfire coming from the area near the gun pits. It is of no surprise to me that one of the lights the Boy Scout unit was talking about would eventually be captured as photographic evidence on the property. The photo was taken near a cannon, and the light anomaly that streaks across the picture just above the cannon forms an image that appears to look like a lightning bolt.

There are also other accounts of many tourists who visit the location. Bright, circular-looking light anomalies with energy striations radiating from the orbs are found in their photos. Are these experiences the lights, visions and sounds of the battle that is still being fought in the spirit world? Are they a remnant or energy signature that still remains because of the tragedies that took place there? Or are these lights really ghosts that are attempting to manifest visibly? The one thing that we can be certain about is that Crooked Creek is an extremely haunted location, and the spirits of soldiers there are not shy about what took place on that soil.

THE BATTLE OF SELMA

It was no surprise that Selma, Alabama, was one of the key operational cities for the Confederacy. The production of supplies, such as ironworks and ammunition for the war, was spread among facilities, factories and naval yards throughout the city. On April 2, 1865, near the end of the war, the famed Battle of Selma took place.

On March 22, 1865, Brigadier General James H. Wilson led a large-scale mission of about 13,500 Union cavalry on a raid into North Alabama to destroy the state's ability to support the Confederacy's war effort. The raid was known as Wilson's Raid and was focused mainly on Selma. Wilson's intent was to destroy the Confederacy's last remaining industrial centers in Alabama in order to debilitate its weapon advantage. The Battle of Selma destroyed the city. It was one of many Confederate obstacles that ultimately resulted in the Confederacy's surrender.

Selma's industry was a massive artillery resource that consisted of more than one hundred buildings and employed as many as ten thousand workers. The facilities manufactured cannons and other military items, including four ironclad warships. Supply problems had slowed down production throughout the war, and this left Selma as one of the last remaining production facilities under Confederate control. While many of the men were at war, businessmen, women and children were working to produce their supplies, such as powder, canteens, clothing, ammunition, shot, shell, cartridges, cylinders and cannons. A young girls' schoolteacher named Mary Jane even closed down her school and took all her girls to work in the facilities

making cylinders and cartridges to help the war's cause. Wilson's Raid was considered one of the most successful operations during the war.

Lieutenant General Nathan Bedford Forrest was in command of about five thousand soldiers, but they were unsuccessful in slowing down Wilson's advance. The Confederate army was just too scattered around Central Alabama and had limited equipment to fight back. En route to Selma, Brigadier General Wilson spent one week destroying other industrial sites throughout Central Alabama. He then arrived on the outskirts of Selma on April 1, 1865.

Brigadier General Phillip Dale Roddey's Alabama Brigade, Colonel Robert McCullough's Missouri Regiment, Brigadier General Frank Armstrong's Mississippi Brigade, Colonel Edward Crossland's Kentucky Brigade and Brigadier General Daniel W. Adams's state reserves were all part of Forrest's men. Lieutenant General Forrest had not attended any military training and, in later days, became the focal point of studies at West Point United States Military Academy. Forrest was just a Tennessee native who became rich as a slave trader and plantation owner. He was, however, naturally gifted in battlefield tactics and was not afraid of engaging in battle. He personally killed more than thirty-one people with his own hands during the Civil War.

Forrest attempted to stop the Union cavalry at Ebenezer Church but failed when he was wounded. The Confederates were forced to retreat and raise their defenses in Selma. One of their outer defenses consisted of a line of entrenchments that was three miles long. There were also Confederate defensive artillery positions set in place that circled the city. Some of these defenses were prepared months in advance and were even located along the bank of the river on both sides of the Alabama River; however, their inner line of defenses around the city had not been completed. Wilson's forces were joined by a civil engineer who had recently changed sides and was instrumental in helping to design the Confederate defense. He provided Wilson with sketches of Selma's earthworks. Also in the Union favor, General Wilson captured a Confederate courier who was able to provide information concerning the whereabouts of Forrest's forces.

On the morning of April 2, Forrest could gather only about four thousand soldiers to help defend Selma. Many were old men and boys who lacked military experience. Because Selma's defense was originally designed to protect the city with troops numbering about twenty thousand, the front positions were very separated, and the Confederate soldiers were located several yards from one another. The city could not effectively be defended,

and Forrest therefore advised the ranking Confederate officer, Lieutenant General Richard Taylor, to evacuate and leave on the last train out of Selma. While Taylor began the evacuation, Wilson divided his command into three units and arrived outside Selma's defenses that afternoon, launching a frontal assault on the Confederate works. This, in turn, accelerated the start of the general attack in Selma.

Wilson had made sure that his troops had good horses, good equipment and good firearms. The Union soldiers were armed with seven-shot Spencer repeating carbines, while the Confederates were inadequately trained and poorly supplied with mostly muskets. Because the Confederates had very little ammunition, the Union troops overpowered Confederate resistance. The Spencer repeating rifle could shoot seven times without having to round home a load or reload at all. Both sides also fought hand to hand, but the Union forces were successful in breaching the city's outer defense within thirty minutes. Many of the Confederate soldiers retreated to guard the city's inner defenses and briefly slowed the Union advancements; however, they were unsuccessful, as the Union cavalry stormed the city. General Wilson led one of the charges into the city, but his horse sustained wounds, and he was dismounted briefly. Forrest and hundreds of Confederates fled the city after setting fire to twenty-five thousand bales of cotton. Because of the darkness protecting them while they attempted to retreat, they were able to make their way to the Alabama River to escape capture. However, many of the 2,700 wounded Confederate soldiers were captured by Union cavalrymen, as were their field guns. The Union suffered 359 casualties. Poor recordkeeping during the final weeks of the war left Confederate deaths in Selma unknown; however, the causalties were extensive.

Wilson's troops were successful in completely destroying all the manufacturing processes and equipment, including fifteen seige guns, ten caissons, ten heavy carriages, ten field pieces, sixty-three thousand rounds of artillery ammunition, 3 million board feet of lumber and ten thousand bushels of coal. The arsenal, ordnance center, gunpowder works, nitre works, ironworks and foundries were all destroyed, and much of the city was burned. Because all the horses were killed during the battle, all their bodies were taken to the center of town and burned. The Union forces had no means to remove the horses from the town, so they resorted to setting them on fire in the center of town to get rid of them. Reportedly, the smell was horrific. There were also several instances of looting, regardless of Wilson's orders against this.

After Forrest's defeat in Selma, he still refused to surrender until he received word of General Robert E. Lee's surrender in Virginia. Because of Forrest's role in the Fort Pillow Massacre and the founding of the Ku Klux Klan, Selma gained national and international notoriety throughout the years as heritage advocates drew criticism from civil rights activists.

CAHAWBA'S PRISON

During the Civil War, no battle was actually fought at Cahawba, Alabama's first state capital, but thousands of Union prisoners were held captive at Cahawba's prison, Castle Morgan. An unfinished cotton warehouse was used as its primary structure, designed to hold bales of cotton brought into the frontier land by railway to Old Cahawba town. The cotton bales remained in the warehouse until they were shipped out by boat. When the Civil War erupted, Confederate authorities soon confiscated the iron rails from the railroad, resulting in the end of construction on the warehouse.

In honor of Confederate general John Hunt Morgan, the Cahawba prison was seized and opened in June 1863. Although there were only 432 bunks, the prison became home to 660 prisoners of war within months. By 1865, the prison held more than 3,000 men, many of whom were captured in the Battles of Athens and Sulphur Creek Trestle in Alabama. The prison was surrounded by a large stockade to provide more room for prisoners. Two cannons were aimed at the prison to stop attempts of riot or mass escape. Environmental conditions were deplorable at all Northern and Southern Civil War prisons, including Castle Morgan, but Cahawba ranked among the least deadly of the war's military prisons. Historians estimate that as many as 147 men died while confined there. The water supply was polluted, the structure contained only one fireplace and the area only measured 125 by 200 feet. The men suffered from disease, insufficient food and a lack of clothing, medicine, shelter and even firewood. Union general Ulysses S. Grant's decision to end all prisoner exchanges resulted in the suffering endured by the men in prisons. About 2,300 prisoners were released from this prison at the end of the war and loaded onto the steamboat SS *Sultana*. The boat exploded near Memphis, Tennessee, and thousands of soldiers were killed in the tragedy. The site of Castle Morgan is now part of Old Cahawba Archaeological Site near Selma.

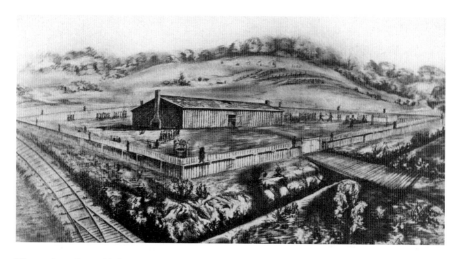

Illustration of an old Civil War prison called Castle Morgan in Old Cahawba Town, Selma, Alabama. The site held hundreds of Union prisoners, many of whom perished upon returning home while aboard the SS *Sultana*. Old Cahawba was the site of the state's first capital. *Courtesy of the Library of Congress.*

Many people have claimed to hear voices around the old fireplace that still remains there. Some have even said that they have seen figures out of the corners of their eyes. Recently, a ghost investigation team visited the location to validate the claims of paranormal activity. The team members did not see any apparitions, but they did hear voices and registered very high readings on their EMF meters, which could indicate a ghostly presence at the prison. Are these the figures and voices of soldiers who were imprisoned at Castle Morgan? Are they still reliving the deplorable conditions and their extensive fears? Are they trying to communicate for their release?

PEGUE'S GHOST

In 1862, Colonel Pegue's home was a brick building in Cahawba that was originally a jail during the capital period. Colonel Pegue had the building renovated with additions and alterations to become one of the more socially active locations in town, and it became the highlight of the community. The house was beautiful, with gardens, fountains and artesian wells. They made it very suitable for family living. People would come and sit on the veranda and just talk and share stories. It was one of the loveliest homes in Cahawba. In

the back of the house, there was a geometric maze of cedar trees. Everyone who came to the Pegue place wanted to take a walk in the cedar maze, and it became a popular pastime because people would have trouble finding their way out of the maze, and everyone enjoyed the game in that. Many young people, such as courting couples, would go back into the woods to walk in the maze and just enjoy the moonlight. Some just wanted to enjoy the maze to escape the horror of the war.

Near the location of Colonel C.C. Pegue's home, there is a ghost story known as "The Glowing Ball" or "The Specter in the Maze." On one evening in June 1862, a young Confederate soldier, Harmon Lee, who had been visiting his family, as well as a young woman whom he had loved for quite a while, came to visit the Pegue family. Some say that it's quite possible that the soldier and his love were bringing news of their engagement to the Pegue family. Like many other young couples, they decided to take a stroll through the cedar maze. While in the maze, they saw a luminescent glowing white ball hovering a few feet above the ground. It frightened the girl, but the soldier believed that there must be a logical explanation.

However, the glowing ball seemed to be playful in nature. It came near them and darted away. As the couple moved left, the ball of light would move left. As they would move right, the ball would move right, but it would always remain out of arm's reach. It would move from one side of the maze to the other, bouncing back and forth. It was almost as if it was laughing at them, maybe even taunting them. Since the soldier had thought that it might be a trick of the moonlight just filtering through the clouds, the couple then turned around to go back in the same direction in which they had come. Again, the glowing ball just reappeared right before their eyes. The soldier told his young love not to be frightened and that the next time it appeared he would catch it. He said that there had to be a way to explain this. The next time it appeared, the young man decided to test to see if the ball was tangible or not, so he reached out to grab it, but then it just disappeared from sight. It instantly reappeared again as if it was taunting them and saying that he couldn't catch it.

They hurried out of the maze and went back to the Pegue house. Everyone back at the house laughed at them, telling them that they were moonstruck. They never saw it again that night. They were the first couple to see the strange light but not the last. Since then, other visitors at Cahawba, such as tourists, hunters and fisherman, have seen the strange glowing ball of light in the mystical cedar maze area, and eventually it became known as "Pegue's ghost." No one can seem to catch it. Some people theorize that

in 1862, it may have been a warning, as months later, Colonel Pegue was mortally wounded in a battle while fighting with the Confederate forces in Virginia. Others think that it was a different warning since Colonel Pegue returned to Cahawba to recruit soldiers for his Fifth Alabama Regiment, the Cahawba Rifles, and many of those men never returned from battle. No one is completely sure, but it has been seen by many people since that time. So, could this light really be a ghost trying to manifest, and if it's not Colonel Pegue himself, then who is it? Will we ever really know?

CAHAWBA'S SLAVE

Cahawba has many Civil War sites that lead back to some of the most intriguing stories. The Bell Tavern was used as a hospital for both Union and Confederate soldiers. The grave of Confederate soldier Augustus Hatcher Jackson, who was buried alive, was relocated to the New Cemetery

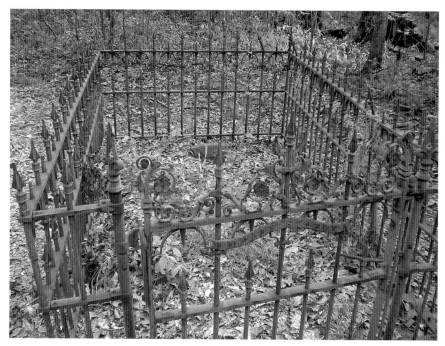

An elaborate iron fence marks the grave of slave Amelia Stark. After emancipation, she lived with her husband and three girls in Cahawba. This grave is part of the slave cemetery where the key-stealing slave Plez is also buried. *Courtesy of Jim Whitcherman.*

of Old Cahawba. So it doesn't surprise me that there would be many stories about ghosts in Selma or even Old Cahawba. It goes without saying that there would be a legendary story about a local family by the last name of Bell who lived in Cahawba.

The Bells were a well-known family who owned a slave named Plez. The local legend is that Plez was forced by the family to go around town and steal store owners' keys out of the storefronts. After Plez brought the keys back to the family, during the middle of the night, the family would go back and steal out of the stores. They would take whatever they wanted from the stores, but because they didn't want anyone to know that the store had been burglarized, they would then light a match to burn the store down. This activity continued for quite some time. The rest of the story tells that there have been several reports of visitors who have lost their keys over the years and other reports that maintenance keys around Cahawba have come up missing. After the keys have being missing for quite some time, the keys are eventually found in the old slave cemetery, right near the grave of Plez, who was the family's key-stealing slave.

The Wounded Soldier at Kenan's Mill

Once again, we step back in time to a circa 1860s gristmill in Selma named Kenan's Mill. It was built in the mid-1800s and produced water-ground cornmeal and grits for more than one hundred years. Local farmers and town residents would drive their wagons full of corn to the mill to have it ground into meal. The grounds also include a fascinating nineteenth-century brick charcoal kiln. Kenan's Mill was built by Zebulon Butler for the Valley Creek community and acquired by Colonel Thomas Kenan and his wife, Mary Rand, in the 1830s. The Kenan family moved to Selma in 1833 with nine of their children. Another son, Owen Kenan, stayed in North Carolina to operate the old historical plantation home, Liberty Hall. The Kenan family continuously owned and operated the mill until Elizabeth Kenan Buchanan donated it to the historical society in 1997. However, there is some speculation about the mill regarding a letter written by one of the sons, James Kenan, in 1861. It notes, "Our corn meal is but just finished and we are debating the question of putting up a flour mill." Perhaps James just meant that the old mill was being renovated and they were adding on.

On the grounds, there is also a swinging bridge crossing over Valley Creek and the charcoal beehive kiln on the other side. The old mill stands high on the wooded bank, suspended over the rushing brown waters of Valley Creek. There are weatherworn boards, still bearing the marks of a craftsman's tools. On the wide-planked floor inside the mill, an occasional beam of sunlight will seep through the cracks.

As use of local gristmills declined, the mill survived by serving local grocers, and a miller lived in the residence until 1968. The mill property also once served as a water park. Four of the five Kenan boys lived in Selma, and it was said that one of the boys, most likely James or Daniel, operated as a town physician, so both the home and mill served as a hospital for soldiers. General Forrest used the mill as a rendezvous point during the Civil War. Many wounded soldiers were helped during the war.

The stones of the mill are the original millstones. Running at top speed, the mill could grind one ton of meal in a day. Local historians tell of stories where farmers and families would come to the mill the evening before. They would sleep under their wagons so they could be the first one in line to get their items ground quickly. The mill was a very lively area. Some could even say that it was almost like a trading post of that era. The three main structures are the mill, the millhouse and the charcoal kiln. Visitors can stroll across the swinging bridge over Valley Creek to get to the brick beehive-shaped charcoal kiln that produced charcoal for use as blast furnace fuel. The wonderful old dated millhouse on the property held residents such as the miller. Just looking at the home and mill, it's not difficult to believe that the mill and house were home to more than just their human inhabitants.

The millhouse on the property was not built until the late 1800s. However, the Kenan family had a Greek Revival home that was located just about two miles down the road. Their farm and pastureland consisted of 1,100 acres, so the family helped with everything to keep the plantation running. The house itself was in the direct path of the Union cavalry heading to destroy the arsenal and gun works during Wilson's Raid when it came through Selma in April 1865. Finding no one home, the Union troops piled furniture in the parlor and set it afire. But the home didn't burn down because servants who had been hidden rushed to stop the fire as soon as the troops were gone. However, there remains a large area of a burn mark on the floor that is still visible in front of the parlor fireplace.

There have been many accounts of tales at the gristmill that have circulated around Selma. The location is now open to the public for events.

Kenan's Mill, Selma, Alabama. This circa 1860s gristmill, with enormous forty-eight-inch water-powered gristmill stones, turned as the gates were raised to allow Valley Creek's water through the tunnel under the mill to reach the turbine. This is the site of many odd occurrences, voices and apparitions.

Area residents told us about some of their experiences there while visiting the location. Cameras have malfunctioned while taking video recordings, and the residents refer to the footage as being "fuzzy." They also claim that they have noted mists moving in front of the camera. Others have reported being touched on their buttocks, all while feeling a burning sensation in the area; however, the area on the body is extremely cold to the human touch. Could this be a frisky ghost? Still others have talked about their pant legs being touched, almost like a cat grazing your leg.

Visitors have also reported apparitions of a white man with overalls on, an African American man (possibly a slave who worked in the mill), white mists floating inside the gristmill on the stairwell and red flashes of light appearing out of nowhere. People also related that they would get extreme chilling sensations all over their body, see strange lights streaking across the room in the mill and feel like someone was just staring at them, watching them. They said that they felt a presence with them and that they were not alone. Some have heard a voice say the word, "Kenan." Visitors have also

caught video of dark shadow people with eyes peeking around the large wooden beams in the mill.

One evening, a visitor to the mill stated that she heard a male voice say, "Help me." She felt a touch to her leg and looked down. She stated that as she looked down, she saw an apparition of a Confederate soldier who was wounded, dragging himself across the ground and pulling on her leg, as if he was seeking medical attention. Some accounts from local residents claim that they feel disoriented inside the mill, but another location that seems even more heightened with activity is the charcoal beehive kiln. At the kiln, visitors have sustained physical confrontations, including their clothing being pulled so hard that it caused one visitor to loose her balance and step backward.

Interestingly enough, many of the odd occurrences are said to happen during the late evening and nighttime hours. Also, none of the accounts have appeared to be very threatening or malevolent in nature. Some people can't help but wonder if this is just the Kenan family believing that they still live there. For the most part, the activities at the mill remain very harmonious during the day, with a few exceptions of blurry photography here and there. Could this state of harmony during the day be because Mr. Kenan is overseeing things? Is this a case of when the cat's away, the mice will play? Is this nightly activity the work of Mr. Kenan himself? Could it be the slaves who lived on the property asking visitors to leave the location because they were trying to produce charcoal? Are these cries for help from soldiers who were wounded? Or could it possibly be the man who drowned in the creek just outside the mill area? Regardless of whoever or whatever still remains at Kenan's Mill, there is absolutely no doubt that there is a supernatural force there attempting to get the attention of the living.

THE CIVIL WAR NURSE AT VAUGHAN SMITHERMAN

Located in the main town of Selma, the Vaughan Smitherman museum was orignally built in 1847 and was used as a girls' school. It has never been used as a home. It has, however, also served Selma as a Confederate Civil War hospital, the Dallas County Courthouse, a Presbyterian military school and the Vaughan Memorial Hospital. The museum houses treasures from a theater, Civil War munitions, hospital memorabilia and railroad exhibits. Could the objects on the property be the reason for this ghostly activity?

The Vaughan Smitherman Museum served Selma as a Confederate hospital, the Dallas County Courthouse, a Presbyterian military school and Vaughan Memorial Hospital. The site is supposedly still haunted by a Civil War nurse trying to help her patients. *Courtesy of the Library of Congress.*

There have been several accounts of strange things that have happened in the building. Given the fact that it has been used as a hospital many times, it is not unlikely that ghosts that still walk there.

There are accounts of footsteps coming down the stairs, occasionally toilets will flush of their own accord and the elevator runs all by itself. Footsteps have also been heard on the hardwood floors on the third level of the building. This is the area that was re-created to resemble the hospital. There have been accounts of people who claim that they heard footsteps that sounded like a nurse (who had big heels on) wearing regular shoes like any nurse would wear. There is another account in which the glass globe of a hurricane lamp was lifted up and then slammed down onto its holder. Due to some other coincidences and factors involved in the scene, it is believed that this was an act of William Rufus King's ghost. King was the founder of Selma, a United States senator and a vice president.

At one time, the facility employed the use of an electromagnetic device that seemed to light up in response to certain questions. Could the ghost

in the building be a Civil War nurse who served the wounded soldiers of Selma? Does she still feel like she is on duty, caring for the wounded, sick and dying? We must remember that the number of soldiers who were wounded in Selma's famous battle were significant, and many needed medical treatment at Vaughan Smitherman. Does this nurse feel as if she still has an obligation to save these soldiers' lives?

Although we cannot be sure that the ghost who slammed the lamp was Mr. King, could it be possible that the ghost was, in fact, a Civil War soldier who had passed due to wounds that he had sustained? Is he trying to send a message and let people know that he is still there? Whether the ghost is a nurse, a Civil War soldier or even Mr. King himself, there is no mistake that the ghostly activity at this location is something worth noting.

Ghostly Sounds of Battle

Although I enjoyed the wonderful day of the Battle of Selma reenactment, the sound of the cannons firing nonetheless made me think about what it was really like for these soldiers when they were in battle. While observing the re-creation of tactical formations, fighting, horses stomping and the wounded being dragged off the battlefield, I came across some reenactors who were more than willing to share some stories with me. They often will stay the night and sleep at the encampments, portraying what it was really like for a soldier in the war while they were in battle.

I found that many people loved to share their stories, including a story about the Manchester ghost seen on the battlefield going behind a tree to relieve himself. After he is finished, he then leans up against the tree and just looks at people. However, the one story that stood out to me was when a reenactor told me of his experience one night on the battlefield that he has never told to anyone else. He said that he was still dressed in his Confederate attire and decided to take a walk on the battleground to check in and talk to his family. He was about half a mile away from the camp. Up to that point, he had never witnessed anything that appeared to be supernatural in nature. He said he saw several animals running around the area, including a few deer and rabbits. It was an amazing sight with the moonlight shining down on the field. He could also hear the crickets chirping. What a wonderful place to be, right in the center of nature. Of course, we have our modern-day conveniences, and he had just gotten off his cellphone with his son because

he didn't want to disturb any of the other reenactors on the battlefield who were trying to sleep.

As he began walking back toward the camp, the reenactor said that he heard a loud thunder in the field, as if horses were at full gallop. He then heard laughter and what sounded like marching across the field. He could hear clanking noises as if canteens and guns were banging up against the sides of the soldiers. He said that he rubbed his eyes a few times to get his vision to focus harder, but he could never see anything on the field. The moon was bright, so he was sure that he would have been able to see this grand event, but he only experienced the sounds. He got this very weird feeling that what he had just experienced was a supernatural event. However, he was determined to find out what had really happened. All of the other reenactors were in their tents, and there were no drills taking place at the time. The next morning, he was unwavering about finding out who was drilling on the battlefield, so he asked the other reenactors in the camp if anyone was on the field that night, but no one came forward to say that they were out there. He never told anyone about his experience, but after making sure that no one was on the battlefield, he knew that he had experienced a supernatural encounter.

Perhaps soldiers were still drilling on the other side. Perhaps they were having some fun, laughing and joking around to pass the time away. Or was this just an imprint of energy of what truly took place at the location in a past event? Regardless, the man said that it felt good to hear laughter rather than fighting taking place. After that day, he became a firm believer that we are not alone.

THE BATTLE OF MOBILE BAY

Founded in 1702 as the capital of the Louisiana Territory and located on the Gulf of Mexico, Mobile has many ghost stories to tell with the influence of Native American, French, British, Spanish, African, Creole and Catholic heritage. Magnolia Cemetery is one of the oldest cemeteries in the Southeast and is the final resting place for 1,100 Confederate soldiers. The city's USS *Alabama* Battleship Memorial Park is a showplace for military history. Just as if you were visiting any other historical town in Alabama, you will most likely hear a good local ghost story. You'll hear chilling stories of Civil War soldiers, haunted riverboats, resident ghosts at plantation homes, ghostly visitors of universities and campuses and many more tales of souls that met with early, tragic or unnecessary deaths. It goes without saying that this would definitely include the city of Mobile. In Mobile, you don't have to believe in ghosts to hear the chilling past calling to you.

Mobile Bay was seized in 1813 by the U.S. government. The British wars of 1812 proved to Congress that the area severely needed adequate defenses along the southern coastline. The goal of the new Fort Morgan was to prevent any enemy forces from entering Mobile Bay. In 1817, Fort Morgan became an important stop on the Trail of Tears as the U.S. Army briefly used the fort to hold Creek Indians who were being forcibly transferred to West Indian Territory, in what is now Oklahoma.

In 1819, construction of a fort on Dauphin Island began, but over the next thirty years, there would be problems that halted its construction—land disputes, water entering the works at high tide and more money being spent

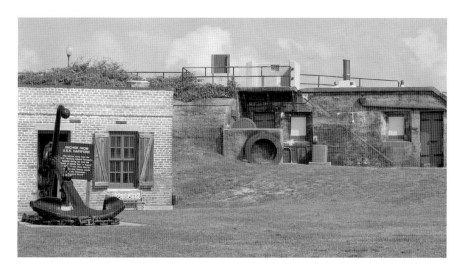

The Fort Gaines south gun ramp provided access to the gun platform for both soldiers and ammunition. The bakery and blacksmith shop are located to the left in the courtyard.

than was allowed. Construction of the original fort designs were abandoned until 1853, when Chief Engineer Joseph G. Totten decided to incorporate advanced military architecture into the fort. Congress also renamed the fortification in 1853 in honor of Brigadier General Edmund Pendleton Gaines, who had died in 1849. By 1861, much of the construction on the fort had been completed, but by 1862, the Confederate States of America had added the final touches. Fort Gaines played a major role in the Battle of Mobile Bay, which was one of the most notable naval conflicts in history.

After the departure of the Spanish from Mobile in April 1813, the Americans built an earth and wood redoubt on Mobile Point, ultimately naming it Fort Bowyer. The fort was named after Colonel John Bowyer, who completed the construction before leaving in 1814. The fort would withstand British naval and land attacks before the Americans would surrender the fort in 1815. When word reached them that the Treaty of Ghent had been signed, the British withdrew. The fort's site was a logical one for a more substantial, much-needed fort that could defend itself from land and protect the entrance to the bay. This led to Fort Morgan replacing Fort Bowyer. In 1818, the United States contracted to build a large masonry fort on Mobile Point. The fort had undergone construction by several military engineers over the years—the incompletions were mostly due to their untimely deaths and illnesses. The army finally turned

the task over to Lieutenant Cornelius Ogden, who completed the work in March 1834. Then Ogden turned the fort over to Captain F.S. Belton, commander of Company B, Second U.S. Artillery.

The city of Mobile wasn't just the site of one of the most historic Civil War battles; it was also crucial to successful Civil War strategies. Because Mobile rested at the head of a large bay supplied by river systems and also connected the eastern and western halves of the Confederacy by railroads, it was instrumental in shipping cotton over these routes from Alabama plantations, as well as exporting ammunition and other supplies needed to the rest of the Confederacy. This railroad system allowed the Confederacy to move troops rapidly by railway, which was essential to victory in many of the major Civil War battles.

Mobile was considered the Paris of the Confederacy, even though it had shortages inflicted by the Civil War. It was still abundant with dance halls, theaters, gambling houses, coffee houses and saloons. Many young Confederate soldiers and sailors were stationed at Mobile, while others were sent to local hospitals in order to recover from wounds or illness. Medical conditions in the war were primitive, and if a soldier got shot in the arm, they would just cut it off. Some soldiers simply passed through Mobile on their way to other Civil War battles. The Battle of Mobile Bay comprises more than a dozen Civil War sites where action took place during both the battle and the Overland Campaign.

The Battle of Mobile Bay took place between August 2 and August 23, 1864. Union forces wanted to close blockade running. Blockade runners were fast, lightweight ships capable of evading naval blockades. To get through the blockade, these ships would have to run at night and cruise by undetected. The typical blockade runners were privately owned vessels operating with letters issued by the Confederate States that provided permission to cross international borders. These vessels would carry cargoes to and from ports with destinations such as Cuba and England. Inbound ships usually brought badly needed supplies and mail to the Confederacy, while outbound ships often exported cotton, tobacco and other goods for trade and revenue.

On August 5, 1864, at 7:30 a.m., Admiral David Farragut's fleet of eighteen Union ships, containing ironclads and wooden steamers, boldly entered Mobile Bay, passed the forts and received a devastating fire from Forts Gaines and Morgan, as well as other points. Inside Mobile Bay, Admiral Farragut encountered Admiral Franklin Buchanan, the Confederacy's only full admiral. Buchanan was waiting in defense with his flagship, the CSS *Tennessee*. The *Tennessee* was deemed the most powerful Rebel ironclad

ship since the *Virginia*, which Buchanan had also commanded around 1862. Inside the bay, Buchanan also had two other ironclad ships that were less efficient, the *Baltic* and the *Nashville*. However, they were severely underpowered, lending them to not be of much value in naval combat. Because of Buchanan's formation of ships in the bay, Farragut decided that he was not going to fight his way in until he had some ironclads of his own in his command. By June's end, Farragut had four in his possession. Buchanan had been a naval officer for forty-nine years, with an illustrious and lengthy career, but his counterpart, David Glasgow Farragut, who commanded the Union fleet, had a fifty-one-year naval career that rivaled it.

On August 1, 1864, Farragut planned his attack carefully. He had to worry about the CSS *Tennessee*, the *Nashville*, the *Baltic* and the two twin forts guarding the entrance to the bay. Fort Morgan, the star-shaped masonry fortification, was armed with heavy guns, any one of which was capable of sinking any of his wooden ships. In addition, there were mines, called "torpedoes," that the Confederates had placed in the channel. The smaller Fort Gaines was located on the western side of the bay's mouth. Farragut hoped to run past the enemy forts right into the bay, and he did not intend to battle it out with the forts. His strategy was to just make it past the forts and through the minefields and then worry about the CSS *Tennessee*. His plan was to advance his ships in two columns—one on the right (because it was closer to Fort Morgan) that consisted of his four monitors (wooden steamships) and the *Tecumseh* in the lead, and a second column to the left and slightly behind. His wooden warships were placed together because he felt that the bigger ships would absorb the bulk of the fort's guns and screen the smaller ones. If any became disabled, they could pull out easily.

At the last minute, Farragut's captains were successful in convincing him to let his sloop of war ship go first. The *Brooklyn* was a formidable fighting ship that could deliver damaging broadsides with a single ten-inch gun and twenty nine-inch guns and had already served gallantly attacking Confederate forts and other installations on the Mississippi River. His captains did not want Farragut to get hurt early in the fight, as they felt it would impede the attack and decrease morale. So, Farragut agreed to allow the *Hartford* to go second in line behind the *Brooklyn*.

On August 5, as the Federal warships approached, the Confederate soldiers in Fort Morgan fired their shells around the leading ships. The Union returned fire, but the white smoke from their guns began to mask their formation. Union captain Tunis Craven on the *Tecumseh* spotted the CSS *Tennessee* and began to edge over to the left in order to intercept it. It was

Craven's job to shield the wooden warships from the CSS *Tennessee*; however, Captain James Alden, in command of the *Brooklyn*, ordered his ship to stop because he noticed that they were dangerously near the buoys that marked the edge of the minefield. Farragut was not aware of what was happening ahead, so he ordered a hoisted flag signal that meant "Go ahead." Alden answered by a wigwag message, which he believed was faster than flag hoist. When an army signal officer read the wigwag message, which was telling them that the monitor ships were pushing the *Brooklyn* toward the minefield, Farragut again ordered Captain Alden to go ahead because both columns were under fire from the fort.

At that moment, Union captain Craven's monitor ship, the *Tecumseh*, hit one of the Confederate torpedoes. The ship's bow heaved up out of the water, and within twenty-five seconds, from explosion to sinking, the ship was gone, with only a handful of survivors in the water. The *Tecumseh* carried 150 of its crew to a watery grave. Meanwhile, the *Brooklyn* was coming closer to the minefield on the left, but even though Farragut had ordered Alden to keep to the center of the channel, it was clearly an impossible task. Alden could not go forward without heading directly into the torpedoes. Again Alden ordered the engines stopped. Because Farragut was afraid of confusion and disorder, he decided to take matters into his own hands. He also did not want his ships to collide with one another. Admiral Farragut ordered his ship, the *Hartford*, to pull out of formation and engage past the *Brooklyn* directly through the minefield. The other ships followed behind in his wake, for they knew that if he made it through the torpedoes, they would too. Some sailors claimed that they had heard the snapping on some torpedoes, but no more exploded probably due to faulty primers. It was clear that Farragut's vessels would survive the charge into the bay, except for the sloop *Tecumseh*.

Meanwhile, Admiral Buchanan was watching all of this from the CSS *Tennessee*. The Union squadron was heading out of the minefield, with the *Hartford* leading. Buchanan ordered an attack but met with frustration because his ship's top speed was only six knots. The *Hartford* easily outmaneuvered the *Tennessee*, even though both ships were firing at each other. Buchanan failed to make contact with any of the other Union ships as well. At that point, Buchanan felt that his position was futile and ceased his attack. He ordered the CSS *Tennessee* back to Fort Morgan.

As Buchanan headed back toward Fort Morgan, he inspected his ship and noted that the damage to his ship was very minimal. The exterior surface of the ship (such as handrails and smokestacks) had been blown away, but much still remained solid and intact, including the engines. He was not

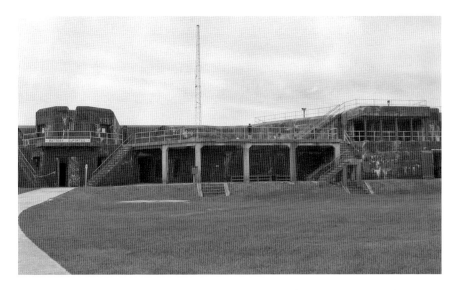

The Battery Duportail at Fort Morgan, Mobile, Alabama. The concrete gun emplacement was mounted with two twelve-inch breech-loading cannons, known as disappearing rifles, capable of throwing a 1,046-pound shell up to eight miles.

about to let the Federal troops off so easily, so he ordered the CSS *Tennessee* to head directly into the big fleet, followed by three smaller defending gunboats: the *Selma*, *Gaines* and *Morgan*. Many brave Confederate sailors protested because they felt it was suicide, but Buchanan held steadfast to his orders. Farragut was surprised that Buchanan wanted to renew the battle. He did not hesitate to give orders. He ordered to aim the *Hartford* directly at the CSS *Tennessee*, which was approaching his vessel. The three smaller gunboats were soon disabled. The *Hartford*, moving forward at ten knots, and the *Tennessee*, moving forward at four knots, steamed directly at each other. It only took fifteen minutes for the two ships to connect and scrape past each other, virtually touching. Men used any weapon at hand, shooting, stabbing and screaming insults.

In less than an hour, the *Tennessee* had slipped past the *Hartford* and was surrounded by Federal warships. They were firing as fast as they could load. The Union's double-turreted monitor ship, *Chickasaw*, fired fifty-two shells into the *Tennessee*. Buchanan could not return fire because one gun port was jammed, and the primers regularly misfired on his other five guns. As a shell smashed into the casemate directly opposite where two men were working on getting the gun port released, Buchanan, who was supervising the effort, was struck by flying debris. He fell to the deck, and the two men died instantly.

Buchanan suffered a severe compound fracture, and the cry went up that the admiral was hit. The *Tennessee* was doomed. Due to sufficient damage, the *Tennessee* could not steam, could not maneuver and could not shoot. James D. Johnston, flag captain of the *Tennessee*, was placed in charge and wasted little time. He instantaneously lowered the Confederate flag, tied a white handkerchief to a boarding pike, and raised it above the ship. The battle ended, and the firing stopped at 10:00 a.m. Combined casualties from both armies totaled 1,822.

After forcing the *Tennessee* to surrender, by August 23, 1864, Union forces had seized both Fort Gaines and Fort Morgan, which controlled the mouth of Mobile Bay. The city, however, was never captured.

After the war was over, on July 26, 1866, Congress named David Glasgow Farragut full admiral. Just as Franklin Buchanan, the Northerner who fought for the South, had been the first Confederate admiral, so too did Farragut, the Southerner who fought for the North, become the first admiral of the U.S. Navy.

Farragut's charge into Mobile Bay in August 1864 may have been one of the most dramatic moments of the naval war, comparable to Pickett's Charge at Gettysburg.

THE KEEPERS' GHOSTS AT FORT GAINES

After the surrender of the CSS *Tennessee*, Farragut turned his attention to Fort Gaines and a smaller fort, Fort Powell. Fort Powell was destroyed, and from August 6 to August 8, 1864, the fight for Fort Gaines raged on. Colonel Charles Anderson, commander of Fort Gaines, ordered his eight hundred men to hold at any cost and continued to battle the Union army. The fort was under siege both by land and sea, all day and night. Nearly three thousand Union infantry were in the entrenchments west of the fort and blasted the fort with their cannons. The monitors of the naval fleet also closed in to almost point-blank range and opened fire with their one-hundred-pound cannons. The fort's thirty-two-pound cannon was no match against the ships. The shells merely bounced off the fleet's tough armor. The garrison returned fire and took cover as best it could in the fort. Many of the Confederate soldiers had seen action at Shiloh, but several young boys ages thirteen to fifteen were engaged in their first battle at Fort Gaines. By August 6, all but one of the guns had been destroyed.

On August 7, the *Hartford* lowered a small boat into the bay and bore a truce flag. It rowed to the fort and demanded surrender. Colonel Anderson and the Confederates sensed that a victory was hopeless, so they boarded the *Hartford* and met with Admiral Farragut. The admiral served the Confederates some wine. He discussed the forces against them, and Anderson decided that it would be suicide to continue with any defense. On August 8, 1864, Fort Gaines surrendered. It is believed, by personal testimony of Confederate ancestry, that nearly five hundred men died at the fort during the war. Parts of bones and human skeletons have been found all over the fort.

Just thinking about these gruesome tales of the battles in Mobile, one could see why many spirits may not be at rest within these fort walls. Phantom footsteps have been heard around all areas of historic Fort Gaines. Cold spots have been felt as well. Apparitions of soldiers all over the fort, described as spooky figures, have been observed by tourists and park employees. There have been accounts that people who leave the fort are sometimes followed by an apparition that appears to be checking up on them. It then disappears after the living leave the front gates.

Fort Gaines's blacksmith demonstrating operations in the blacksmith shop. The blacksmith drill press and anvil are used for making horseshoes and other materials. Many restless spirits still walk these rooms.

There is a story about one of the fort keepers who would often spend the night in the bedroom above the gift shop. The story goes that the keeper awoke to a man standing at the foot of the bed. Although he couldn't see the apparition itself very well, he could see the brass buttons on what seemed to be a Civil War–era coat. He also said that on another day, he looked out at the middle of the fort toward the powder magazines. The big doors in the middle section were opening and closing by themselves. The odd part about this is that the doors are very, very heavy, and no one has ever seen them open or close from just the wind.

The fort's blacksmith, Mr. Ralph Oalmann, spoke of a personal experience where he had his bed in a particular location upstairs in the bedroom area above the gift shop. Sometimes when they perform in reenactments, he will sleep at the fort. He retold a story about a small gust of wind that would blow on the back of his ear several times while trying to sleep. Almost nightly, when he would sleep there, he would be woken up by this small gust of wind that only blew on his ear. He said he got so tired of it that he decided to move his bed, and it never happened again. He noted that there were some dark, creepy places in the fort that would make the hair stand up on the back of your neck. He added that he has heard many stories from visitors about purple lights, noises, voices and sounds of footsteps.

The Tunnel Ghost of Fort Gaines

The tunnel areas of the fort are, well, just plain creepy. You can almost feel the energy, like people are still walking through them. A visitor to the fort named Crystal photographed an image of what appears to be an apparition down at the end of the tunnel. The location in the photo where the image appeared is exactly where a soldier died from dysentery. Another testimony from a fort visitor claims that he saw a soldier on guard walking across the top of the quartermaster's building. Yet there was another tourist who claims the battle is still going on there at the fort. He was recording video of his trip to the fort, and when he got home, he played his video and realized that he had captured a fascinating gunshot. He believes that it occurred as a remnant of the past. The most interesting part of the story is that there was a voice on the recording that claimed to be the spirit that was shot. When I heard about this story, it didn't surprise me too much to learn that other visitors of the fort have also claimed to hear gunshots as well, but audibly

rather than on recordings. There are many testimonials that visitors of the fort will often see visions of soldiers in the tunnel and hear gunshots as if the Battle of Mobile Bay is still going on.

Ezekial: The Confederate Ghost

There's a common local story about a Confederate soldier named Ezekial that has circulated on Dauphin Island. It begins with the story of a local businessman who was walking down the tunnel of Fort Gaines toward the bastion. He said that he saw a large Confederate soldier floating toward him. While staring in amazement and fear, he said that it appeared as if the bottom part of his body had been blown away by a shell or something. The soldier looked right at him and told the man that his name was Ezekial and that he needed to get out of the fort immediately.

A local historian also tells of seeing the apparition of Ezekial in one of the fort's rooms. She claimed that the feeling is just awful when people stand in that room and that the coldness goes right through your body. She is hesitant to go into that room because she doesn't want to see Ezekial again. A local fisherman has seen the ghost of Ezekial pulling the torso of his body. He said it was very unnerving. I would imagine this gruesome sight would be a very disturbing scene to watch. It sounds like Ezekial is still very upset that he was fatally wounded in the battle at the fort. I can't imagine why he wouldn't be upset. If he was very young, had his body torn into pieces and lost his life, I could see why he would want to warn people to leave. Either Ezekial is still upset, or he is consciously attempting to warn others to leave before they get hurt in battle too. It's clear that Ezekial does not appear to be resting in peace.

Primitive medical treatments consisted of mostly just two things: sawing off body parts and using leeches to suck the disease out of someone's blood. If anyone got hit with a bullet and it hit bone, a surgeon wouldn't hesitate to just saw off a body part in the operating room without any anesthesia, antibiotic or any other medical devices. They would just simply use a saw. Can you imagine what kind of pain that was for a soldier? Can you imagine the excruciating agony? If anyone was sick with disease, such as dysentery, they would place leeches all over the soldier's body in the hopes that the leeches would suck the disease out. This was called bloodletting. I can't even begin to imagine the gruesome scene or what kind of feeling it would be

to have leeches crawling all your body for hours, especially if you're sick with something as terrible as smallpox, pneumonia or dysentery. Normally, leeches fall off after about two hours, but they would just replace them with new ones as needed.

There is a very intense presence of many spirits at Fort Gaines in the tunnel; they are angry and not at rest at all. At night, sometimes you can almost feel the presence of the spirits reach out and touch you, according to park rangers. Many of the soldiers were chained together in the fort, and some were even buried alive or blew up together as cannons misfired. When the prisoners were actually captured, some of them would be branded in the blacksmith's shop as a form of torture. They would take a hot poker stick, stick it in a fire, heat it up red hot and stick it to the soldier.

The soldiers who were suspected of slipping secrets to enemy soldiers were tortured in various ways. Soldiers of the Civil War were treated very harshly. Enemy soldiers would do all kinds of horrendous things to them to try and get the information they needed, or sometimes even just for amusement. One of the most effective methods of psychological torture was water torture. They would tie the soldier's head, arms and legs extremely tight down to a table so they couldn't move and allow water to drip onto their foreheads, intending to enrage the soldiers, making them go insane. If prisoners tried to escape, they would be put into the neck stock in the POW cell. They would be left so long that they would get tired and just eventually pass out. The weight on their neck while passed out would eventually strangle them and kill them.

In the watering cistern hole in the east bastion, soldiers would try to get out of the fort through the pipe lines. Many got caught in the pipes as high tide came in and drowned. At the east bastion, people hear noises such as bricks moving around. At the west bastion tunnel, six Native American men were captured as slaves, chained together and held in the tunnel. There was a misfire of one of the guns above them at the fort, and the tunnel collapsed on them, burying them alive. The remains were never removed from the location.

The spirits seem resentful that visitors come into their space. The rangers say that the spirits that are haunting Fort Gaines do not realize that the battle is over and that the war has ended. It is definitely one of the most haunted places in Alabama. Some visitors say that they can never go back there.

THE SHEEP-SKINNED INDIAN WOMAN

The land that Fort Gaines was settled on once belonged to the Indians. There were many native settlers who lived on Massacre Island before French, English and American industrialization. The island's French history began on January 31, 1699, when the explorer Pierre Le Moyne, Sieur d'Iberville, arrived at Mobile Bay and anchored near the island. He named it "Isle Du Massacre" (Massacre Island) because of a large pile of human skeletons discovered there. The gruesome site turned out to be just a simple Indian burial mound that had been broken open by a hurricane, not an actual massacre site; however, the name stuck.

There is local legend at Fort Gaines that an old Indian woman feels responsible for the sacred land that was there before any of the settlers came. They say that she is still at the fort overseeing visitors. She is dressed in animal skin, and her face is weathered with wrinkles. They say she has contempt for any living person who desecrates the location. Is it possible that some of these ghosts are the people who lived on Massacre Island? Is it possible that these poor soldiers just keep reenacting the same scenes over and over again, hoping and waiting for a different outcome? Are there resentments for the war and the atrocities committed there? Is this why they are still manifesting after their death?

THE MANY GHOSTS OF FORT MORGAN

Fort Morgan was designed to allow its defenders to bring a heavy concentration of fire on an enemy fleet as it approached the fort. Because of its position, the fort was designed with land defenses to withstand any siege by the enemy. Fort Morgan was seized by Southern troops in January 1861 because it was considered strategic to Southern control of Mobile Bay. Earthwork water batteries were constructed outside the main walls of the fort, and mines that could be triggered from the fort were placed in the channel. Fort Morgan received the brunt of the famous Union attack, with cannon fire rocking the ground for several miles as the fleet of eighteen ships commanded by Admiral David G. Farragut stormed into Mobile Bay on August 5, 1864. Union rifled cannons and warships decimated the brick. Fort Morgan still bears the battle-scarred remains of the Civil War.

Admiral Farragut's fleet came within range of Fort Morgan at 6:30 a.m. Massive gunners in the fort opened fire. Because the USS *Tecumseh* hit a mine and was blown up, the entire Union fleet came to a halt within point-blank range of the fort's heavy Confederate cannons. At that moment, it appeared that the Union attack might fail and the guns of Fort Morgan might actually turn back the Union fleet. It was at this critical moment that Admiral Farragut gave his famed orders, "Damn the torpedoes. Full speed ahead!" Fort Morgan surrendered three days later.

Entrenchments were dug and artillery placed, but on August 9, 1864, Union troops landed east of the fort and a formal siege began. The fort battled for two weeks, but after several days of gunfire, on August 22, 1864, the Union army and navy fired more than three thousand shells into the fort, shattering brick and dismounting the Confederate cannons. General Richard L. Page was finally forced to accept defeat, but only after spiking his remaining guns and destroying thousands of pounds of powder. He then raised the white flag on August 23, 1864.

As we covered the roads in Mobile, the local residents sent us to Fort Morgan because of the ghost stories there. Fort Morgan has seen action in the Civil War, World War I and World War II, so it's no surprise that there would be reported activity at the location. Visitors have reported footsteps, moving shadows, ghostly whisperings and even full-body apparitions.

What people don't realize is that the white sand all around the fort was once soaked in soldiers' blood. Fort Morgan's history is rich with battle, bloodshed and misery. Visitors at the fort report seeing dark shadows in the walkways, tunnels and rooms. People have heard disembodied voices and what sounds like prisoners still scratching at the walls of their cells. Some tourists have complained about hearing a man crying just after sunset near the barracks, where a prisoner hanged himself in 1917. Nearby residents tell of eerie glowing lights and encounters with dark figures dressed in period clothing walking the beach embattlements after dark. Some visitors at the fort have reported hearing the sounds of gunfire and smelling the odor of gun smoke. After sunset, there appears to be an increase in audible moans and cries from wounded soldiers. Some people even find themselves face to face with the fallen soldiers. Could these dark figures also be some of the slave workers who helped build the fort before the Civil War?

THE MOANING GHOST

"I'll never forget this as long as I live," said Josh, a visitor to Fort Morgan. The man was quite visibly moved; for him to tell his story was not an easy task. He stood with fingers rolling and hands shaking. He did not claim to have any psychic ability or any sensitivity to the paranormal at all. He stated, "We were walking around the back of the fort on the grass area and proceeded to go back into the fort. It was quite dark in the tunnels in the back of the fort." He continued to walk through the passageways, making his way back to the front of the fort toward the entrance. He said he heard a small faint moan near the prison cells and footsteps in the outer hallways. He then heard a noise that sounded like crying and more moaning. It was very loud and lasted for about three seconds. As he was walking through the tunnels, he saw a soldier coming toward him. He was dressed in period clothing, and he could see the soldier's Confederate uniform. He said that he could never adequately describe the vision because it was like when you see a bright light and then you look away—the outline and image remain in

Casemate tunnels of Fort Morgan, Mobile, Alabama. Smoke and fire filled these vaulted rooms during the Battle of Mobile Bay.

his memory, but the figure was translucent and you could see through it. Is this one of the Confederate soldiers who guarded the fort during the Battle of Mobile? Was he hurt and looking for someone to comfort and help him?

Another story from a visitor to the fort notes that he was on the beach one night with his girlfriend. They were the only two people on the beach because it was quite late at night, around 10:30 p.m., so it was fairly quiet, and they could hear the wind blowing. They then heard a very loud and clear sound of a person whistling coming from the fort. They were about three hundred yards away, so they decided to walk closer to the fort. They never found anyone. He said that the whistling sounded like it was coming from inside. There were no vehicles in the parking lot other than theirs, and no one was ever found walking around the fort inside or out. Could this be one of the long-forgotten slaves who was instrumental in building the fort? Could this be a Civil War commander just taking a stroll? Or could this be a Confederate soldier patrolling the fort, whistling while he worked?

THE SPANISH INTRUDER

In the artillery bunker, visitors have reported that the heavy wooden doors close on their own, while other stories have been told about a Spaniard appearing to a visitor of the fort. A tourist named Camilla told us her story about her visit to the fort. She said that she had been riding for hours in the car and had to go to the restroom as soon as she got to the fort. She noted that as she made her way to the restroom, she felt a presence behind her. She proceeded to the restroom reluctantly because she didn't know what was going on with the feeling of someone watching her. She had to use the restroom so badly that she didn't care who it was at that point. But she felt very uneasy, especially since she had just arrived at the location and was already having weird and odd sensations.

She went into the bathroom and proceeded to a stall in order to use the facility. Suddenly, an apparition of a man who appeared to look like a Spaniard (most likely a Spanish soldier) appeared right in front of her. He just smiled and then said hello in a very friendly and flirty manner. He seemed to be nonthreatening and very kind. She said that the apparition scared her because she was not expecting to see anything, especially in the restroom. It took her breath away, and she felt that she had to get out instantly. She immediately finished up and left the stall of the restroom.

She washed her hands very quickly and frantically got out of there. She continued to described him as being authoritative looking, and his clothing was dark colored, consisting of dark blue, black, ivory and deep red. He had a coat with gold and brass buttons on. She said that it appeared almost as if he was a commander of some sort.

She said that she just sensed a "Spanish" feeling radiating from him. He had on what looked like a Spanish uniform, with a morion, a type of open metal helmet used during the sixteen and seventeenth centuries, usually having a flat brim and a crest from front to back. The morion, although generally identified with Spanish conquistadors, was common among foot soldiers of European nationalities, including the English. Although she had never seen Spanish or English uniforms and was unsure of the kind of uniform it was, she was sure that it was a uniform of some military status.

After hearing this story, I performed some research and found out that Old Mobile did, in fact, have both French and Spanish residents in the early seventeenth century living near the coastline. I also found out that the French and Spanish single men would enslave Indian woman and use them as concubines and housekeepers. Did this man feel like it was okay to be a bit too friendly while interrupting a woman in the restroom? Did he have concubine slaves? Could he have been one of the Spanish explorers or soldiers who landed at Mobile Bay in the seventeenth century? If so, well over three hundred years have passed! I find it phenomenal to have seen a sixteenth- or seventeenth-century apparition at Fort Morgan. We may never know who the man was, but at Fort Morgan, we do know that history may literally reach out and touch you.

THE BATTLE OF FORT MIMS

Fort Mims was located on the plantation of Mr. Samuel Mims and was a stockade with a blockhouse and outbuildings located just about thirty-five miles north of Mobile, Alabama. Some four hundred American settlers, African American slaves and Creek Indians who allied with the United States had taken refuge inside the fort due to rising concerns and tension between the two divisions of the Creek Nation. The native Indians were called Red Sticks because they had raised the "red stick of war," a symbolic war declaration, named for the red wooden war clubs that they carried as weapons. The Red Sticks argued against engaging with white settlers, while the other, more modern Creeks favored adopting the white lifestyle. Leaders Tenskwatawa and Tecumseh advocated death to any Indians who allied with the Americans, as they preached adherence to traditional Indian practices. I suppose greed, misunderstandings, vengeance and fear all contributed to this war. The Creek Indians were generous neighbors, but there came a point when they couldn't give anymore. They feared losing their land, traditions, their way of life and all that went with it.

Sam Dale, one of the greatest Indian fighters, was Chief William Weatherford's best man at his wedding. This was not just a fight between nations, like we may think. This war was about neighbors fighting neighbors, and kinfolk fighting kinfolk. This battle was a civil war, but many of the Creek Indians who were allied with Andrew Jackson wanted a peaceful nation. There were other forts around, but the Red Stick Indians who were leading the attack hated Creek captain Dixon Bailey. He was their enemy for

a number of reasons, including actions at the Battle of Burnt Corn. So, the attack that was made on Fort Mims included retaliation because it was also a blood fued against Dixon Bailey.

The war among the Creeks erupted in the summer of 1813 because the Red Sticks were determined to destroy the community of Creeks who had established plantations. Major Daniel Beasley of the Mississippi Volunteers and Captain Dixon Bailey of the Creeks had a force of 265 armed soldiers consisting of 70 Tensaw home militia, 175 Mississippi volunteers and 16 soldiers from Fort Stoddard, all of which resulted in 517 people staying at the fort. The soldiers and citizens awaited reinforcements.

Weatherford was initially against the attack at Fort Mims because he had family at the fort. Even though his relatives were inside the fort, he eventually decided that his loyalty had to be with his people, the Red Sticks. He wanted to just go in and take over—let it be a quick war—but because of the mistakes that Beasley made, it ended up being a massacre. Weatherford was so appalled that he tried to stop it, but they threatened to kill him, so he left.

On August 29, 1813, two men sent outside to tend cattle for the stockade reported that an unknown number of "painted warriors" were in the vicinity. A command sent out a detachment of horsemen, but the men found no Indians. Major Daniel Beasley dismissed it and took no precautions. They said that the major had been drinking. Beasley threatened to flog one of the men for imagining such a story, but he rode off.

At that time, the militia was often commanded for political gain rather than military knowledge. Major Beasley was in charge because he was a military appointee and obtained that position because he was friends with the general of the Mississippi militia. Major Beasley was a lawyer by training and had been elected chair. He was not trained in military tactics; however, he was convinced that just because he was there, no Indian would dare attack. It became apparent that he didn't understand the Indians. Captain Dixon Bailey, a Creek who was in charge of the militiamen, many of whom were also Creek, understood sage warfare. Beasley did not. Beasley made many mistakes because he chose not to listen to his intelligence and to the slaves who told him that the indians were near. They say that Beasley felt that he knew more because he had been politically appointed. If he had listened to his military intelligence, he could have defended the fort. He also did not listen about placing the portholes for firing at shoulder level. Beasley felt that it was better that they wouldn't have to stand on anything to shoot out. Unfortunately, this also meant that

the people on the outside could also shoot in just as easily, which is one of the reasons the fort was taken from the outside.

On August 30, 1813, chief warriors Peter McQueen and "Red Eagle" William Weatherford (also called Billy Weatherford) of the Red Stick Indians, with a compiled force of about one thousand Creek Indians from thirteen Creek towns, commenced an attack on Fort Mims. At the time of the attack, the east gate was partially open. With the beat of the drum sounding off for the call to midday meal, the Red Sticks knew that the people in the fort would be occupied. It was very easy for them to cover the ground from the woods to the gate before it could be closed because most people were eating. The Creek warriors attempted to take the fort by taking control of the portholes, charging through the open gate and defeating the militiamen who were stationed inside of the gates. Most of the militiamen were found dead near the front gate, so they were definitely doing their job trying to defend the fort.

Once the Red Sticks were inside the fort, they were screaming their heads off and swinging war clubs while charging their enemies. Imagine trying to load a gun or rifle while this is taking place. Once the Red Sticks infiltrated the fort, they didn't use guns; they used their warclubs because it took too long to load a gun. The Red Sticks knew what they were doing. It was very effective warfare. Too many tactical mistakes had been made on the part of Beasley—not listening to sage advice, not knowing his enemy, not knowing their way of warfare and being drunk.

At three o'clock, there was a brief pause in the battle. Red Eagle recalled about one hour into the fight that he attempted to talk the Red Sticks into leaving the fort, but they refused and threatened to kill him if he tried to interfere. At that time, Weatherford rode off in disgust to meet his brother nearby, telling him what was happening. The Red Sticks met in council and decided that Dixon and the fort would have to be destroyed to avenge their treachery at Burnt Corn. The battle continued. Half of the Mississippi Volunteers died with their commander, Major Beasley, in the first few minutes of battle. Major Beasley did act bravely as he tried to secure the gates, and he did die bravely, by all accounts.

Creek captain Dixon Bailey, with his American and Creek militiamen, battled the Red Sticks for four hours, successfully defending hundreds of civilians in the fort. Only when the attackers set the fort's buildings on fire with burning arrows did their resistance collapse. Red Sticks slaughtered 250 defenders inside the fort, with the exception of a few who escaped. By five o'clock, the battle was over. The stockade and buildings lay engulfed in

flames. Captain Bailey was mortally wounded; however, 36 other men and the captain himself were able to escape. The Red Sticks took captive about 100 slaves. When relief finally arrived a few weeks later, it found 247 corpses of the defenders and 100 of the Creek attackers dead.

The killing, butchering and scalping of white settlers consisting of civilian men, women and children outraged the U.S. public, which demanded governmental action, thus prompting U.S. military action against the Creek Nation. The Red Sticks' attack on Fort Mims ranked as one of the greatest successes of Indian warfare; however, the massacre of the civilians brought together U.S. forces, which resulted in the victory at the Battle of Horseshoe Bend on March 27, 1814.

In the 1830s, the Creeks were forcefully removed from the Southeast due to the continuing outrage surrounding the Fort Mims Massacre. Partially because of the attack on Fort Mims, Andrew Jackson was able to move into the presidency—Tennessee raised so many volunteers under the command of Jackson that it became known as the Volunteer State. The Red Stick Creeks had caused so much turmoil in Tennessee that when the people of that state heard about Fort Mims, they came to Alabama to help fight at the Battle of Horseshoe Bend. The victory there was one of the first steps in Andrew Jackson claiming the presidency. After the massacre, soldiers from other forts in the region came to bury the dead. By the end of the battle, there were an estimated 350 to 500 dead bodies inside the fort, many of them Creeks and half-breeds. Not much remained of Fort Mims. The hundreds of graves eventually became covered by a blanket of foliage.

The Uneasy Ghosts of Fort Mims

Hundreds of people lost their lives at this location, considered to be one of the most brutal massacres in history. That also means that it soon became one of the most haunted places in the South. The bloodshed, the tragedy, the fight and the terror are all remnants of this horrific battle. To think that there could actually be souls resting in peace at this location—utter nonsense. The moment you step foot inside the fort structure, you can instantly feel a change in the air. People have said that they feel depressed and sad when entering the fort. Some have a sense of panic that overcomes them. Visitors have heard the sounds of battle cries involving Indians, men, women and children, almost as if they were right smack in the middle of the battle itself.

A direct descendant from the battle explains that she has been to Fort Mims and has heard the war cries. One of her family members who was at the fort that day decided to go get some supplies when the attack happened, so his life was spared, but her other ancestors at the fort were not so lucky. The entities do not seem to display any awareness of their living observers. Is the descendant really hearing the voices of her ancestors as they were being massacred? Is this residual activity being witnessed by the living occuring from a scene that was so gruesome, horrific, bloody and tragic that it left its imprint within the land of the fort? Are the visitors of the fort experiencing a form of time displacement? Are they actually involved in the battle that's transpiring on the otherside? The fort is said to be haunted by these restless spirits, most of whom were friends of Red Eagle. But still, after a century and a half, war still rings in the stillness of the night at the old fort. Will these spirits ever rest in peace? One of the bloodiest slaughters ever recorded in American history is almost forgotten and is even unheard of by many people living in this country today.

THE AXE AT THE PASSAGEWAY

Near the passageway where more than thirty men escaped, there are stories that circulate about people hearing an axe as it cuts away wood, making a hole in the wall. When I told Bryan, a local resident, that I was interested in ghost stories, he told me that he had an encounter with a restless spirit who long ago fought in the Battle of Fort Mims. He was visiting the fort one day, and his hair was standing on end as he approached the escape passageway. Now, he had heard stories about the passageway before, but he had not experienced anything at the fort until that day. He said that others have claimed to hear an echoing of battle cries and men's voices, but they never could understand what was being said.

As he walked near the escapeway, he said that he felt a push on his shoulder, almost as if he were being pushed out into the direction of the escapeway, almost like a herd of bulls stampeding. He said that this was followed by noises of what sounded like people panicking and screaming for their lives. He then heard a man's frantic voice cry out, "Get out of here!" Bryan felt like he was in the center of the battle and that the ghost was facing desperate circumstances. He is sure that the ghostly man did not want his life

to end by massacre. Other visitors to the fort have said that they have heard children talking, but when they turned around, no one was there. Still others have audibly heard both male and female voices of what sounds to be an Indian spoken language.

GHOSTLY DRUMBEATS OF BATTLE

Another descendant, named Floyd, was trying to keep that legacy alive by journeying and collecting data about his ancestors. Floyd is a direct descendant of the famous Creek chief who led the attack on Fort Mims in Alabama. He knows the story well, as he had heard the tale since he was a young boy. He made a visit to Fort Mims to gather information about his genealogy, but he is still bothered by his experience at the fort, almost thirty-six years later.

It was rather late at the fort, so he and his friend decided to set up camp for the night. He could not sleep, so they built a fire to keep warm. Shortly after settling down, they began to hear unusual noises. They sounded like moans. He rose up but didn't see anything, so he lay back down, thinking that it was just his imagination. His buddy then jumped up, looking around because he said he heard footsteps close by. No one was there. Well, now both men were wide awake, so they just stayed up with the fire.

At about 1:00 a.m., near where the east gate had been, they heard six loud drumbeats. This was where the entrance was located when William Weatherford and his warriors entered the fort on the day of the massacre. The men said that the noises increased after the sound of the drumbeats. Floyd's friend said that he also heard the sounds of horse hooves, cries of human agony, Indian warrior screams, men yelling, women screaming, muffled thuds, children crying, the sound of running feet and all the panic and wild outcry of battle.

Then, at about 2:00 a.m., they heard two loud drumbeats sound over the area where the west gate would have been. Floyd and his buddy stuck it out, but they kept telling themselves that it was just their imaginations. Floyd never believed in ghosts. Floyd's friend heard sounds that seemed so real that it felt as if the massacre were taking place all around him. The two men could not see anything except the land, trees and moonlight casting light on the field. The air was still, and even with the woods around, no animals seemed to move about. At about 4:00 a.m., they

heard one more drumbeat where the blockhouse had stood, but that was the last sound, putting an end to the experience. They were really glad when morning came.

Residents who live near the old fort suggest that the departed spirits of Chief Red Eagle, Major Daniel Beasley and all the victims are still restless. Do they still want to be remembered?

THE BATTLE OF HORSESHOE BEND

United States officials felt pressure from the public to launch an offensive campaign against the Creek Indians due to many battles that ensued in the South. American expansion into Creek hunting lands in Alabama and Georgia, as well as an economic shift, resulted in the Creek Nation seeing an increased division among its leaders. After the Fort Mims Massacre, the United States and the Creek National Council formed an alliance against the Red Stick Creeks.

The Battle of Horseshoe Bend on March 27, 1814, was the site of the last and most famous battle of the Creek Indian War, when the Red Stick Indians secured the neck of the great bend in the Tallapoosa River. Andrew Jackson's army of U.S. infantry, Tennessee militia, allied Creek and allied Cherokee warriors all gathered together against the Red Sticks. Jackson's army encountered a resourceful and ingenious barricade with heavy resistance. In the end, the outnumbered Red Sticks were defeated, and Andrew Jackson was an American hero for bringing to a close the Creek War.

In 1813, the Creek National Council ordered the executions of several Creek warriors who had killed seven American frontier families. The Creeks had been misinformed that the war had broken out. In June 1813, the conflict worsened when Mississippi Territory militia ambushed the Red Sticks, who were returning from Pensacola with ammunition and supplies at Burnt Corn Creek in Alabama. The retaliation came in August 1813, when the Red Sticks stormed Fort Mims and decimated the fort, slaughtering 250 settlers.

At that time, the governors of Mississippi Territory, Georgia and Tennessee launched a full-scale plan to crush the Red Sticks' towns and mobilized their

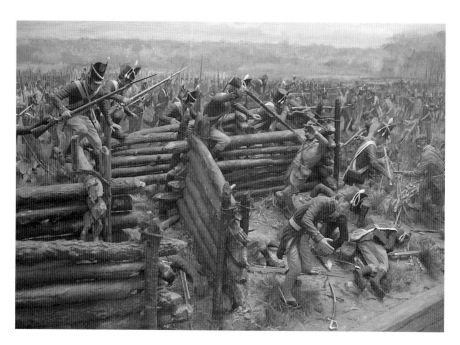

Portrait of the Red Stick Creek Indians' wooden log barricade at Horseshoe Bend National Military Park. Soldiers from the East and West Tennessee militia and the Thirty-ninth U.S. Infantry directed by General Andrew Jackson are seen fighting their way over the barricade.

armies. Major General Andrew Jackson of the Tennessee militia headed south into the heart of Creek country. Jackson's difficulty was that their towns were inaccessible. The numbers were not the problem, as the Red Sticks at war used fewer than four thousand men, and not more than one thousand fought in any single battle. The issues that Jackson had to overcome were the same as any other war at the time: trying to keep troops moving and feeding the soldiers.

During the autumn and winter of 1813, the Red Sticks and their families built the village of Tohopeka inside the horseshoe bend of the Tallapoosa River. There they had hoped for some protection from the river and from a long barricade that they had constructed. They also relied on the magic of their prophet, Monahee, and direction from their chief, Menawa (the "Great Warrior").

In March 1814, General Jackson built a new fort farther south on the Coosa River, named Fort Williams, which was reinforced by Lower Creek Indians, Cherokee allies and U.S. infantry. General Jackson's army marched out, cutting trails through the forest, and in three days, it arrived about six miles north of the so-called Horseshoe Bend. On the morning of March

27, 1814, General Jackson sent Brigadier General John Coffee with thirteen thousand cavalrymen consisting of seven hundred mounted infantry plus six hundred Cherokee and Lower Creek allies three miles downstream to cross the Tallapoosa River so they could surround the one-hundred-acre bend, cutting off any retreat across the Tallapoosa River.

About one thousand Red Stick warriors manned their stout log barricade, which blocked access to the horseshoe. They awaited the attack with supreme confidence because they believed that they would win the battle. Their prophet had told them that they were going to succeed. Behind them, in the Red Stick village in the southern part of the bend, three hundred women and children also waited with mixed feelings. Jackson took the rest of his army, which consisted of two thousand soldiers from the East and West Tennessee militia and the Thirty-ninth U.S. Infantry, into the peninsula.

By 10:30 a.m., Jackson's infantry was approaching the barricade, and due to the shouting challenge of the Red Sticks, Jackson's army replied at noontime with their muskets and two small cannons, firing at the Red Sticks' barricade for more than two hours. Warriors and soldiers desperately struggled to control the barricade—shooting; hacking; stabbing with muskets, tomahawks, war clubs, knives and bayonets; and firing with bows

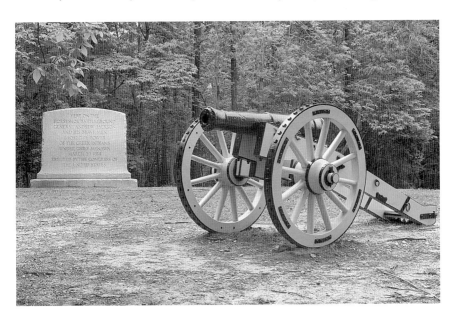

A Horseshoe Bend National Military Park cannon and memorial marker, with the dedication: "Here on the Horseshoe battleground General Andrew Jackson and his brave men broke the power of the Creek Indians under Chief Menawa March 29, 1814. Dedicated by the Congress of the United States."

and arrows. Hearing the sounds of battle, a few men of Coffee's Cherokee army, with deer tails in their hair, swam across the river, stole canoes and began bringing Coffee's men across. This bold maneuver was completely unplanned but succeeded brilliantly. Coffee's force pushed forward, burning the Indian village and attacking the Red Stick line from the rear.

Meanwhile, Jackson gave the order to advance and also ordered a frontal assault that poured over the barricade. The troops rolled forward and took the barricade by storm. The result was no longer in doubt, yet the Red Sticks fought more desperately than ever. Finally, the surviving Red Stick warriors caught between Jackson's forces scattered to the river, hoping to escape, but fate was against them. Coffee's troops had surrounded the bend and took out the fugitives. Just a few hours before the battle, there were 1,000 Red Stick warriors, but by sunset, there was nothing to be seen but large volumes of dense white and gray smoke, rising heavily over the corpses of painted warriors and the burning ruins of the fort and village. When it was done, 557 warriors had died on the battlefield, and an estimated 250 to 300 drowned or were shot trying to get across the Tallapoosa River. Only 49 of Jackson's men died that day, but there were more than 154 wounded. Less than a dozen of the friendly Creeks died in the battle. By sunset, the battle was over, and as the sun went down, it set on the ruins of the Creek Nation.

Fort Toulouse (also named Fort Jackson) was built at the site of an old French fort at the junction of the Tallapoosa and Coosa Rivers. Andrew Jackson went to Fort Jackson with his Tennessee militia following his victory over the Creek Indians at Horseshoe Bend. It was at Fort Jackson where William Weatherford, leader of the Creeks, surrendered and the treaty ending the Creek War was signed. The Creek Indians were forced to give up more than 20 million acres of land to the U.S. government. After General Andrew Jackson was elected president, he signed the Indian Removal Bill, which forced all tribes east of the Mississippi River to make the journey of the "Trail of Tears" to Oklahoma. So many Native Americans died due to starvation, illness and fatigue. The wounds have not been forgotten by many of the slain souls at Horseshoe Bend. They still linger, waiting and hoping.

BLOOD RIVER

This book would not be complete without the haunting tales at Horseshoe Bend, which have circulated among those who have worked near or live by the peninsula. Out of respect for all the lives lost at Horseshoe Bend, I felt

compelled to tell their stories. The Tallapoosa might truly be called a "River of Blood"; even at ten o'clock at night, it was stained so red with warrior blood that it could not be used.

Many of the wounded warriors crawled to what might have seemed to be their freedom until they encountered Coffee's army on the other side of the river. Many of the men probably took their last drink from this river just before dying, while others bled uncontrollably into the river.

Several personal experiences from tourists who visit the river area range from hearing voices to having odd feelings and sensations and experiencing sightings of apparitions, smells and nausea. Some accounts claim that sadness comes over people while overlooking the Tallapoosa River. Some people claim that they have had urges to run away, as if being chased by an unseen warrior while under attack. Other accounts come in the form of screams being heard. There have even been accounts from tourists noting that near the river, they get extremely sick with nausea and turn astonishingly pale. Large bright lights have also appeared that seem to travel around, only to disappear rapidly in a matter of seconds. Is this land so sacred that the ghosts feel they must be heard? Do they want to impress on us what they felt when they were dying during this tragedy? Do they want us to acknowledge the color of war?

Blood River, located at Horseshoe Bend National Military Park. During the battle, Red Creek Indians attempting to escape while crossing the Tallapoosa River were killed by Union, Lower Creek and Cherokee forces waiting on the other side of the riverbank. That night, the river was so visibly bloody that it could not be used. *Courtesy of Gini Brown.*

SACRED VILLAGE

In the meadow of Tohopeka (the village at Horseshoe Bend), there were as many as three hundred log huts that resembled log cabins. Alarmed by the Creeks and Cherokees crossing the river, the Red Sticks began to flee the village before their impending death came upon them. Stories from locals claim that some women and children were able to escape into the woods and hide in a very small cave in the area. Although this has not been confirmed, it has always been a possibility due to the number of wonderful caves in Alabama.

Audible disembodied voices have been heard of women, children and men speaking what seems like a Creek language when no one is around. Tourists to Horseshoe Bend have reported incidents, such as white figures appearing in their photos. Others have reported camera malfunctions and hearing audible disembodied voices that sound like the battle cries of women and children.

Up to this point, we haven't talked much about our own investigations at any of these historic locations, but I do think that this would be a great opportunity to share some of the evidence that the Alabama Paranormal Association has found at the Tohopeka Village.

The APA team actually arrived at the park a bit later than expected because of the many stories being told to us along the way, so we were nearing evening hours. We didn't think that we would capture much evidence since we were unable to actually perform a full investigation at the location. We did, however, utilize some small technical equipment, such as recorders, KII meters and a Frank's box (a device used for capturing auditory two-way communication evidence). When we reviewed our audio, we found that there was a considerable number of American Indian voices that were captured at the village location. They were actually indiscernible at first, but then we realized that the audio we had captured were the men, women and children of the village speaking the Creek language. It sounded residual, just as if the villagers were still going about their daily business.

Other tourists have reported hearing screams of women and children at the village. Could these voices be the villagers trying to send us messages from the other side? Are the screams imprinted remnants of energy that occurred from the villagers being attacked at that moment? After capturing information on audio evidence and comparing that to our EMF meters readings, we realized that we had also received intelligent spirit responses rather than just residual recordings. We wanted to be respectful and not desecrate the land nor cause any spirits to rise up, so we asked a question

to any spirits that may have already been lingering around the land. We asked if the land was considered sacred to them. We received a response from a spirit that sounded Native American in nature. It answered yes to our question. So, let me ask, is there more than one kind of haunting going on at Horseshoe Bend National Military Park? I do believe that there is much they would like us to know about the battle that took place at Horseshoe Bend. I do believe that they are still trying to interact with us to tell their story. I do believe they want peace.

Phantom Sounds at Jackson's Gap

There is a location at Jackson's Gap Creek, not very far from Horseshoe Bend park, where many arrowheads have been found. They were discovered next to a single oak tree. It seems almost as if this was a spot where they would just sit and make things. Is it possible that the Indians may have sat there waiting while hunting bears or sharpening their tools? The sense of the area near the oak tree is that it's a sad place where people have reported apparitions of Indians performing ceremonial dancing in circles right next to the tree. They have heard ceremonial singing as well. Arlene, a local resident and descendant of Daniel Boone, told us about her experiences of walking through the woods near the creek. She said that the wind will start blowing, and then, all of a sudden, you can hear what sounds like chanting coming from the woods. She said that the chanting sounds sad and that there are graves just over the hill from the area near the oak tree. People have also experienced extremely cold breezes in the location. Is it possible that the Indians could still be performing a burial ritual, and is this why the location seems so sad?

Tribal Ghosts

The school at Horseshoe Bend is rumored to be built on an old Indian burial ground and was named in honor of the Battle of Horseshoe Bend, according to the principal, Casey Davis. There have been instances at the school where there have been strange odors noticed in the offices. One member of the school is part of the Cherokee tribe and has actually

performed smudging ceremonies. Sometimes at night, when they work late at the school, they will smell things and see a shadow that comes down the hallway; however, they say that it feels like it's watching over them and protective. Things have fallen in the hallways, and their surveillance cameras have captured shadows when they feel a presence. There is a woman in the Cherokee tribal group there who lives near Horseshoe Bend School, and her land joins up with Horseshoe Bend park. She has a place behind her woods where they found ceremonial pottery and other Native American items. She feels that they try to contact her because she will often look out her window and see images of the Indians down in the woods walking through that area.

Another story that takes place near Horseshoe Bend School, not far from the peninsula, comes from a local resident who was having problems with keys disappearing and seeing white mists in her home. She was hearing noises in her home regularly at night—things clanking, floors creaking and loud footsteps. The home was filled with Indian artifacts that were recovered from her backyard—as the family was excavating to put an addition on the home, the remains of pottery and ceremonial items, such as turtle shells and bones, had been found. She brought the artifacts into her home, cleaned them up and held them for safekeeping.

At this point, she began to have problems in her home. She was often woken up at night and would see white mists floating right by her while she lay in bed trying to go back to sleep. Pictures on the wall were turned and knocked off. Lights would flicker on and off, and she was not sure why all of this was happening to her. She knew that the land had belonged to the Native Americans at one time and that a battle took place not far from there, so she thought that maybe it was related to them.

She contacted a Native American tribe to help her. The tribe members told her that she had probably disturbed the spirits by digging up the artifacts and that some of the items she had discovered were ceremonial pieces. They suggested that the woman sage her home, present a peace offering to the spirits and return the items to the ground in exactly the same location where she had found them. She did this with the aid of the tribal members. Since that day, she has no longer experienced activity in her home. The tribal council told her that if you bother one Native American spirit by upsetting his belongings, other members of that same tribe may follow as well in an effort to help their brother warrior. Even though the Battle at Horseshoe Bend has long since passed into history, the sounds of the battle remain to speak to our imagination.

THE BATTLE OF DECATUR

Decatur, Alabama, was a very strategic location during the Civil War. This small town was an important transportation and supply center. Decatur was located on the Tennessee River and was served by the Memphis & Charleston Railroad during the war. The Battle of Decatur took place over the course of three long days in town. Although Alabama did not experience the worst of the fighting during the American Civil War, the Union forces did not take very long to reach the state. On February 6, 1862, North Alabama came under the control of Union forces as gunboats steamed up the Tennessee River to Florence, Alabama.

Huntsville, Alabama, was occupied by Union forces on April 11, 1862. This was primarily a strategic plan on the part of the Union due to the railroads and river being important routes leading into the Confederate heartland. They had hoped to stop troops and supplies from advancing north, and the Union intended to send the supplies and ammunition southward.

The Battle of Decatur was fought from October 26 to October 29, 1864, as part of the Franklin-Nashville Campaign. Union forces of three thousand men under Union brigadier general Robert S. Granger prevented thirty-nine thousand men of the Confederate Army of Tennessee under the command of Confederate general John B. Hood from crossing the Tennessee River. General Hood was attempting to move his army into central Tennessee in an attempt to reclaim Nashville, Tennessee. The Union army prevented General Hood's Confederate army from crossing the Tennessee River and forced him to move

westward. This delay of four days contributed to Hood's failure to retake Nashville for the Confederacy.

It all started in September 1864, when General Hood and his Army of Tennessee hoped that the Union forces in Atlanta, Georgia, commanded by General William T. Sherman, would take a bait to follow them, but Sherman decided against this and returned to Atlanta, launching his "March to the Sea." Knowing that Sherman was not following him, Hood developed a new plan to retake Nashville, Tennessee. He decided to head north to attack Sherman's railroad supply lines between Atlanta and Chattanooga, Tennessee; however, this would require Hood to move his army across the Tennessee River and into central Tennessee. Hood originally intended to cross the river at Guntersville, Alabama, but strong defenses and gunboats patrolling that area of the river convinced him to search for an easier crossing. Decatur seemed like an excellent location to ford the river because of a Union pontoon bridge and a strategic railroad crossing.

On October 26, 1864, Hood ordered his army to surround the town of Decatur. The Union commander of the District of Northern Alabama, General Robert S. Granger, received word and immediately rushed from Huntsville to Decatur to take personal command of the Union garrison. Granger, an experienced commander who had distinguished himself at the Battles of Chickamauga and Chattanooga, requested reinforcements from General Thomas in Nashville because his force of three thousand men faced Hood's twenty-three-thousand-soldier army. Because of skepticism, General Thomas only sent two regiments from Chattanooga to help reinforce Decatur. Thomas ordered Granger to "hold his post at all costs."

The next day, Hood ordered his men to construct artillery entrenchments in heavy rain because the Confederates faced Union fortifications that consisted of earthworks, trenches, abatis and artillery entrenchments. Later in the day, Hood ordered his soldiers forward, and fighting broke out. The next day, despite thick fog, Granger's Union soldiers fought off some of the Confederate forces. Later in the afternoon, Granger sent out a larger detachment, including the Fourteenth United States Colored Troops (USCT), a regiment of ex-slaves from Chattanooga that held back Hood's forces. Although they were relatively inexperienced, they drove back Confederate artillerymen and disabled two pieces of artillery before retreating back to the safety of the Union lines.

The black troops often faced racial prejudice from Confederates, as well as within their own army, but instead they were greeted with cheers from Decatur's white soldiers. Colonel Morgan reassured all of his men that their

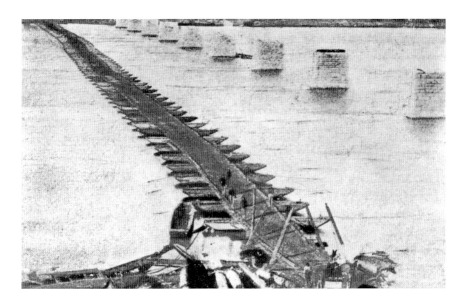

Pontoon bridge in Decatur, Alabama, located on the Tennessee River. This vital and strategic pontoon bridge was fought over by Union and Confederate soldiers during the Battle of Decatur. *Courtesy of the Library of Congress.*

exemplary behavior in battle would silence their critics and elicit praise from their comrades.

General Hood created his own hampering of supplies for his army because he did not communicate with his superior, General P.G.T. Beauregard, as to his army's movements. He felt it would cause delays. This left Beauregard in a position where he was not able to coordinate with the quartermaster's office to supply the Army of Tennessee. This led to many of his soldiers being without shoes and rations. General Beauregard arrived on the night of October 27, 1864.

Because of the lack of supplies, the defense of the Union garrison and the arrival of two Union gunboats, the Confederate commanders decided to retreat because any further action against Decatur would be foolish. On October 29, Hood ordered his army to withdraw from Decatur. On October 30, 1864, eighty miles away, Hood and his Confederate army finally forded the Tennessee River and arrived in Florence, Alabama. Hood led the Army of Tennessee to defeat at Franklin, Tennessee, and to its ultimate ruin at the Battle of Nashville. Because of few official reports of the three-day battle at Decatur, Alabama, estimates of Confederate casualties range widely from 500 to 1,500. Historians can only verify about

210, but in a correspondence to a newspaper in Mobile, Hood stated that the losses were 1,500. The Union reported an estimate of 500 Confederate casualties in Decatur and a total loss of 155 Union officers, enlisted men, wounded and captured. Whatever the true number of casualties, the Battle of Decatur most definitely witnessed hostile military action that resulted in many deaths. The periodic fights between the Union and Confederate forces for control of the railroad bridge over the Tennessee River left Decatur in smoldering ruins.

Only five buildings were left standing near the river when the war ended. The McEntire House was used by both Union and Confederate forces as headquarters during the war. Legends say that the Confederate generals planned the Battle of Shiloh within its walls. Local folklore suggests that the 102nd Ohio Regiment Band played a dirge on the rooftop to mourn the death of President Abraham Lincoln. The Dancy Polk House was also used as Union headquarters, and the McCartney Hotel was used for accommodating enlisted men while the Old State Bank served as a hospital. The Todd House was eventually bought by steamboat captain James M. Todd.

Many Union and Confederate regiments from the countryside were organized in Decatur and were sent out to fight in the major battles in the war. Many of the generals from both sides of the armies—including General Albert Sydney Johnson, General Beauregard, General John Bell Hood, Lieutenant General Nathan Bedford Forrest, General William T. Sherman, General James McPherson, General Robert Granger, General James Steedman and General Grenville Dodge—all fought or gathered troops there.

THE LADY OF THE HOUSE

Built in 1833 at a cost of $9,482, the Old State Bank in Decatur, Alabama, is a very impressive classic Greek Revival building. It originally housed the Decatur Branch of the Bank of the State of Alabama, a newly formed state banking system devised by Andrew Jackson. The banking system failed, and the bank was closed in 1842. For a while, the building was deserted. It then became a private residence until the 1860s, when the war broke out. During the war, the building served as a hospital, a supply depot and a guardhouse. The columns of the bank are said to weigh one hundred tons and were

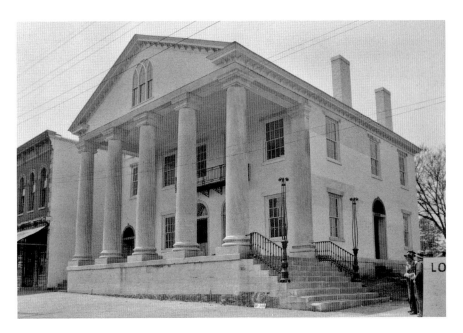

Historic Old State Bank in Decatur, Alabama. It is reportedly haunted by the spirit of a weeping woman, among many other Union and Confederate soldiers. *Courtesy of the Library of Congress.*

crafted on a nearby plantation by slaves, who were set free upon dedication of the building by the plantation owner. By 1864, it was one of five buildings left standing that had not been torn or burned down by Union troops.

The city of Decatur has a battle reenactment every year, with more than two hundred reenactors portraying the battlefield event. The city also has a walking tour of the historic buildings in the town. The Old State Bank not only was a field service hospital but also served as quarters for soldiers for some time during the war. It is a beautiful building and is now used as a tourist attraction. History is embedded within the walls of the building and on the land itself. As you stand on the front colonnade, you can see the direct path of the advancement of Confederate forces, and as you tour the bank, you will find replicas of the Old State Bank's money system. The columns, colonnade and doorway of the Old State Bank still bear scars from Confederate cannons, rifles, musket fire and Minié balls, as the bank was directly in the line of fire.

Since the bank is open to visitors, as we walked the city near the river and battle sites, we came across some local residents who have toured the bank at one time or another. They were able to share several ghost stories

about the bank and surrounding area. A young local resident shared her story about the woman in the window with us. She was standing outside the home to the left of the building while smoking a cigarette because she was waiting for the rest of her friends to finish up their tour (the tours in the building are not overly formal—people can spend a lot of time in the building just looking at all the history that it has to offer). The story goes that she felt a sense of someone staring at her. She felt prompted to look up, and when she did, she saw the top torso apparition of a middle-aged woman dressed in a light blue Civil War–era dress. The dress came up to the neckline, and her hair was pulled up in a bun.

The woman outside could not see the bottom of her body since she was standing at the window. She was just staring at her from the second-floor window. At first, she thought that maybe it was a reenactor in the home, so she finished her cigarette and went back inside the building looking to talk with her. The woman was nowhere to be found. At that point, she realized that what she had seen was an apparition of a female spirit from the Civil War. She felt spooked by the sighting and asked her friends to finish up immediately so they could leave. She left, telling them of her experience. Is it possible that this woman was the lady of the home when the bank was used as a residence? Does this mean that she

Unidentified Civil War–era woman in portrait. *Courtesy of the Library of Congress.*

is watching out for her property? Could she be a nurse waiting for more wounded soldiers to arrive? Is she watching the battle from her window, waiting for the gunfire to stop? The ghostly woman certainly made it known that she was there for a reason.

The Weeping Woman

One evening after a tour of the building, a woman was just sitting on the stairs to the Old State Bank. She was just enjoying the scenery of the beautiful fountain and having a brief resting period. She said she was sitting there relaxing when she felt someone come up behind her. She turned to look and did not see anyone. She said this presence was strong. She turned to look around the area, but again she did not see anyone. She dismissed it as being her imagination at work. She returned to relaxing again and began to watch the bats in the park area across the pathway. She felt it was neat to watch them just flying around the lights and near the American flag that so proudly soars near the Old State Bank. She wondered if they were going to get caught up in the flag. She added that she felt a presence behind her again, but this time it felt stronger. It felt as if someone was right up at the back of her, standing there. She said her hair on her arms and neck started to stand on end, and she became emotional, almost grief-stricken.

She turned to see if there was anything behind her again, and this time she saw a very young woman about the age of thirty or so, with tears falling from her eyes. She appeared to be so sad. She had a plain white Victorian-looking dress on. She said it looked like an old-time dress that women would have worn in the Civil War era. The woman just stared at her with tears in her eyes, just weeping. Her hands were in a prayerful position, and the lines of her face appeared to be articulating that her heart was in agony. Was this woman longing for her family, her husband or her brother? Was she mourning their deaths?

After her appearance, the ghostly woman just disappeared. The tourist said that she felt as if the woman was reaching out to her to let her know how hard times were during the Civil War. She wanted her to know her pain. She wanted her to know that she was in turmoil over the loss of the people she loved so much in her life, whether they were dead or just fighting in battle. The ghostly vision seemed to be asking her to tell her story. She seemed to be reaching out for understanding, sympathy and condolence.

THE SACK OF ATHENS, THE BATTLE OF ATHENS AND SULPHUR CREEK TRESTLE

A thens, Alabama, was a pivotal location in Civil War history. There were many skirmishes and battles that took place there; however, one battle in Athens was destined to change the Civil War forever.

In this section, in order to tell you the story as it truly unfolded, I cannot sugarcoat or embellish the reality of this war. In the following story, I depict the true nature of what happened on those sad days. My intent is only to share the story with you how it is regarded in Civil War history. To tell it any other way would not portray the realistic details of the war in Athens just as it happened so long ago. Some of the following part of this story may be slightly disturbing, but it is my intention to tell the story just how it was. It is my hope that this may help create a larger vision of why there are so many restless spirits still remaining at these battle sites that are angry, upset, sad, mourning or even trying to communicate messages with the living.

In earlier periods of history, treating the enemy with compassion after the battle, showing mercy to civilians or sparing lives on the losing side wasn't even a thought. If the captives were not killed, they were often made prisoners or slaves. It was not until the seventeenth century that some suggested that captives should be treated humanely. We find in war that there is a tendency to dehumanize the enemy, and people just become abstract. Is this the only way to get ordinary people to kill the enemy? Is there really a moral way to fight any war? Did the North and South have an "idealized" version of what "war" was really all about and what it

meant to be a soldier? Do newly enlisted soldiers really know the reality of warfare? Is whether your side wins all that matters?

Some veterans of warfare often speak of the true conditions of war, such as seeing a blinding flash a few yards in front of them causing them to fall flat on their face. Soon enough, they realized that a number of the infantry were carrying mines strapped to the small of their backs or that mines were planted in certain areas, unbeknownst to unsuspecting soldiers. If any rifle or bullet struck one or a soldier stepped on one causing it to explode, it would blow the man into three pieces—two legs and a head and a chest. The insides and other pieces of human beings became litter, spread across the battlefield—headless bodies, legs, arms and shoes with feet still in them. Some found it nearly impossible to even walk yards without stepping on or over death. Many soldiers come back from war traumatized, as in the case of my military friend who couldn't even stay at the Selma reenactment with us because the sounds of the battle, guns and cannons triggered an internal reaction causing his posttraumatic stress disorder to surface.

Many innocent people have suffered in warfare because officers and soldiers wanted revenge or felt that they could do whatever they wanted. Were the conditions of war the reasons they became this way? Starving, deprived, horrified and exposed soldiers—is this what happened to the troops under the command of Colonel Turchin at the Sack of Athens?

What happened in Athens was an atrocity. It was a pivotal point in the war, making the Northern and Southern conflict a total war. After capturing the Memphis & Charleston Railroad and the victory at Shiloh, the Union army moved deep into the Confederacy's homeland. The town of Athens, Alabama, possessed an important depot on the Nashville & Decatur Railroad line that would prove both strategic and beneficial to the Union army.

On April 27, 1862, two Ohio units moved in to occupy the town. There were about nine hundred residents in Athens, Alabama, and they offered to cooperate with the Union because they claimed to be pro-Union; however, the sudden infiltration of Union troops into North Alabama shocked Southern folks. The Union troops, however, had a false sense of security that occupying Athens would be all right. They thought that the presence of the Union army would be greeted warmly since the citizens of Athens had voted for a Northern Democrat in the 1860 election, because of their pro-Union sentiments and due to Athens mayor W.P. Tanner's statement that after the state left the Union, the Union flag continued to soar on top of the courthouse for two months. Tanner also noted that the town's residents found the Union soldiers to be orderly and restrained, so the Union thought

that the town's citizens had previously displayed considerable Unionist sentiment. But what the Union troops really found when they got there was that many residents in Athens had turned on the Union cause and were actually anti-Union.

On the morning of May 1, 1862, the Confederate First Louisiana Cavalry organized an attack on the Union garrison in Athens, Alabama. The Confederate cavalry drove the Union bluecoats from the town, forcing them back toward Huntsville, Alabama. There were cheers and the waving of hats and handkerchiefs, as well as spitting and cursing at the Union soldiers. More than one hundred residents joined with the Confederate soldiers to remove the Union soldiers from the town. Upon returning to the town, the First Louisiana Cavalry members were received as heroes.

However, the next day, just as the Confederates were settling back in town, commanding officer Colonel John Basil Turchin, feeling very betrayed, led a counterattack with the Eighth Brigade, consisting of the Eighteenth Ohio, Thirty-seventh Indiana, Nineteenth Illinois and Twenty-fourth Illinois. The Union forces pushed the Confederates back out of Athens once again.

Turchin was a military-trained Russian, and he believed that the residents' behavior in the pro-Union town was treacherous conduct. In retaliation, he decided to punish the citizens. He rode into the town square and loudly told his troops, "I shut my eyes for two hours. I see nothing." The soldiers, including foreign soldiers, were both angry and tired, so they sacked the whole town.

Businesses were looted and destroyed. The drugstore's medical library in addition to surgical and dental instruments were destroyed. Shop windows were shattered, while jewelry stores, druggists and dry goods stores were vandalized and burglarized. After that, the criminal activity continued on to the terrified private residents. The soldiers searched for valuables while pocketing gold watches, jewelry and silver utensils. Clothing drawers were pulled to the floor, and trunks were pried open with bayonets. Some soldiers just sought out food rations, such as tobacco, sugar and molasses. The officers and soldiers insulted the men and women of the town, although physical violence was kept to a minimum. Soldiers fired their gun into a residential home, unknowingly resulting in a pregnant woman losing her baby. In fact, both the mother and fetus died. Indecent propositions were made to the women of the town, and the soldiers were accused of raping one fourteen-year-old enslaved girl and attempted to rape another servant girl.

When night came, soldiers claimed private homes while chopping roasts on pianos and cutting bacon on the rugs before going to bed. The damage

Young boy soldier in portrait. *Courtesy of the Library of Congress.*

was estimated to be about $55,000. These horrific events became known as the "Sack of Athens." This undoubtedly fueled the animosity between the Southerners and Northerners, as well as a disgust for foreign soldiers.

In 1862, the action initiated on the part of Colonel Turchin and his troops was deeply shocking to American soldiers and civilians; this was supposed to be a gentleman's war. What happened on May 2, 1862? Did

both the North and South set a heavy burden of expectation and values on the volunteer soldier to abide by a commitment to duty, knightliness, bravery, manliness and, most of all, honor while trying to maintain their aggression, fear, self-control and restraint—all while enduring the brutal environmental conditions of war? Was this really an ideal vision of "war"? The Nineteenth Illinois Infantry, one of the units involved in the savaging of Athens, was formed with the help of prewar Illinois militia companies; it reflected such values by requiring its men to swear that they would not enter a saloon, brothel or billiard parlor. It's safe to say that they were not taught to be brutes.

The Union army's reaction to the events that took place during the Sack of Athens and toward Colonel Turchin's behavior was very aggressive. Upon hearing of the incident, area commander General Ormsby Mitchel immediately rushed to the town, met with the victimized residents, promised to punish those responsible and encouraged the residents to establish a committee to complain against the soldiers. However, Mitchel also understood the frustration the forces were under because of Athens residents' betrayal and the Confederates' hit-and-run tactics.

Major General Don Carlos Buell called the incident an undisputed atrocity and ordered Turchin and his men court-martialed to examine the charges against them. For ten days, Colonel Turchin sat before the court-martial while the citizens of Athens testified regarding the abuse they had suffered at the hands of his troops. Brigadier General James A. Garfield was ordered to preside over the trial, initially believing that Turchin's men had committed the most shameful outrages on the country ever seen during the Civil War. Some believed that Turchin's Russian military training had made him too brutal.

In the weeks after the events in Athens, it was found that Turchin disobeyed both Buell's discipline and orders to protect all private property by ordering his men to burn the nearest farmhouse whenever they were fired on from ambush. Regarding the charges and in his defense, Turchin stated, "I have tried to teach the rebels that treachery to the Union was a terrible crime," he said. "My superior officers do not agree with my plans. They want the rebellion treated tenderly and gently. They may cashier me, but I shall appeal to the American people and implore them to wage this war in such a manner as will make humanity better for it."

Brigadier General James A. Garfield received a letter from his wife that reflected the public's view of the proceedings: "I hope you will find Col. Turchin guilty of nothing unpardonable," she wrote. "Severity and sternness

should be turned to the punishment of rebels for the barbarities committed on our boys rather than to the punishment of our own. It seems very strange that as soon as a man begins to accomplish something in the way of putting down the rebellion he is recalled, or superseded, or disgraced in some way."

The Civil War's goal had been to restore the Southern states to the Union. The rebellion was seen as the action of hotheaded minority Southerners. To gain support for the war, newspapers began to criticize the Rebels with rumors of atrocities against Union soldiers. Northerners claimed that the brutal and savage Southern slave systems made Southerners different from other Americans.

Turchin was found guilty but returned to Chicago, Illinois, a hero because of his harsh administration of war directed against the citizens of the South. General Buell ordered Turchin dismissed from the army, but Turchin announced that instead of being removed from the service, President Abraham Lincoln had overturned the verdict of the court and promoted him to the rank of Brigadier General. Turchin himself called for enlisting slaves against their masters. He commanded in the Battles of Stone River, Chickamauga and Chattanooga. In 1864, he retired due to his war wounds.

Many Northerners despised General Don Carlos Buell because of his determination to protect Southern property. His proslavery sentiments found him relieved of command in October 1862. President Lincoln had lost confidence in Buell's judgment because Buell had attempted to scourge Turchin and because he did not aggressively pursue the Confederate army after the Battle of Perryville. The Union army refused to pay a penny of the $54,689 claimed by the victims of Turchin's visit. The Sack of Athens escalated the Civil War. A Chicago veteran of the Athens incident later recalled, "It was pitiful, but it was war."

This 1862 incident was a turning point in the war because Turchin's promotion gave other Union commanders the go-ahead to show the South the full weight of the war. General William T. Sherman's army, Turchin and his men and other Union units, including volunteers, were now seemingly free to invade and would no longer offer any apologies for doing what they had come to do. The act of depriving the Confederacy of needed provisions accelerated the end of the Civil War; however, it also became engrained in the Southern memory.

In the fall of 1863, the Federal army began recruiting black males to serve in the United States Colored Troops Infantry Regiments, the 106th, 110th and 111th USCT. They were primarily freed or runaway slaves from North Alabama and southern Tennessee. In order to protect the railroad, in early

1863, Fort Henderson was constructed in Athens, Alabama, on Coleman Hill. It was an earthwork 180 feet by 450 feet and was protected by the 18th Ohio from Athens.

As part of the continuing fight between the Confederates and Union forces in Athens, Alabama, the Battle of Sulphur Creek Trestle took place from September 23 to September 25, 1864. Some people refer to this conflict as the "Battle of Athens."

After Lieutenant General Nathan Bedford Forrest's involvement in and relative victory against Streight's Raid, Forrest eventually led his force back into northern Alabama and middle Tennessee to disrupt the crucial supply of provisions, supplies, troops, clothing, ammunition and other necessities for General William T. Sherman's army, which was stationed in Georgia. Forrest also wanted to stop the return of damaged goods and wounded soldiers back to Chattanooga. The Alabama & Tennessee Railroad ran from Nashville, Tennessee, through southern Tennessee and northern Alabama to Huntsville and Decatur on the banks of the Tennessee River. From Decatur, the railroad connected with another railroad that extended east into Chattanooga. This line thus provided continuous passage for troop supplies that came off boats on the Cumberland River in Nashville and were sent to support Union forces in Chattanooga. Forrest's force grew (with the addition of General Roddy's men) to about 4,500 soldiers, but he then sent the Twentieth and Fourteenth Tennessee Cavalry to Tanner, Alabama, leaving himself with fewer men.

At sunset on September 23, Forrest and his remaining soldiers moved in to check out the town and Fort Henderson. Just before dark, Colonel Wallace Campbell and six hundred men consisting of the 106th, 110th and the 111th United States Colored Troops defended the fort by firing their artillery. Forrest's command consisted of Bell's and Lyon's brigades of Buford's division; Rucker's brigade; some of Roddy's troops; Biffle's brigade; the 4th Tennessee; and Colonel Nixon's regiment. The Confederates made several attempts to gain possession of the town. The quartermaster's building and the commissary building were both burned down by the Confederates, and by late into the night, the Union troops had taken up safety at Fort Henderson. Under the cover of darkness, another five hundred men of the 3rd Tennessee (Union) moved into the fort. The fort, considered to be the best to resist any field battery between Nashville and Decatur, was an earthworks bastion fort with five points measuring 180 feet by 450 feet. It was 1,350 feet in circumference and was surrounded by an abatis of fallen trees, a 4-foot palisade and a 12-foot-wide ditch.

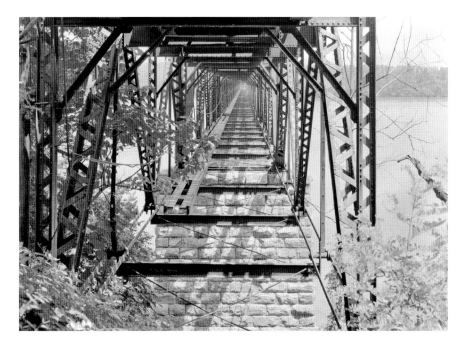

The railroad bridge on the Alabama & Tennessee Railroad that ran from Nashville, Tennessee, to Huntsville and Decatur, Alabama, on the banks of the Tennessee River. *Courtesy of the Library of Congress.*

On September 24, 1864, at about 7:00 a.m., the Confederate army opened fire on Fort Henderson with twelve-pound batteries stationed on both the north and west sides. Forrest's artillery officer opened fire with his eight guns, casting almost sixty shells into the fort but doing very little damage. The Union fought back with two twelve-pound howitzers. At about 9:00 p.m., two demands for surrender sent in under General Forrest were refused by the Union force. At that point, Forrest asked to have a personal meeting with Colonel Campbell to show Campbell that his Union forces were completely outnumbered. Forrest tricked Campbell and told him that he had about ten thousand men at his side, and he demanded surrender.

Meanwhile, General Granger of Decatur had organized and sent 350 soldier reinforcements by railroad early the next morning to help reinforce the garrison in Athens. However, because the railroad along the way to Athens had been taken overnight by Confederate forces, when the Union units arrived early the next morning, they were attacked by Buford's division. The Union troops fought the Confederates while driving them back, all the way up to about three hundred feet from the fort. Unfortunately, by the

time they got to the fort, they found that Colonel Campbell had surrendered about half an hour earlier.

The surrender of the fort allowed the Confederates to turn their attention to the relief troops from Decatur, the 18th Michigan and 102nd Ohio Infantry. After three hours of fighting and suffering casualties of one-third their total soldiers, the Union forces surrendered. Forrest's men had captured 1,300 prisoners, three hundred horses, two pieces of artillery and a large amount of supplies. The Union officers claimed that Campbell should have never surrendered the fort because they had ample supplies to last them a siege of at least ten days while awaiting reinforcements. They said that the water well in the fort had plenty of water, and there were 70,000 rounds of elongated ball cartridges, an ample supply of cavalry carbines and 120 rounds for each of the howitzers. The Union officers said that the surrender was against their wishes. The Federal loss was 106 killed and wounded; Confederate loss was equal to the force engaged.

On September 24, 1864, after the victorious defeat of Union forces in Athens, Forrest advanced north with about five hundred cavalry and infantry soldiers intending to destroy the strategic railroad trestle at Sulphur Creek, located about six miles north of Athens. The trestle stood 71 feet high and stretched 561 feet across a deep gorge. The battle over the Sulphur Creek Trestle railroad bridge would be the bloodiest land battle to take place in Alabama during the war.

Union forces of the Ninth Indiana Cavalry and Tenth Indiana Cavalry had constructed a fort at Sulphur Trestle in order to protect the vulnerable railroad supply line. It was located on a hillside alongside the railroad tracks about one mile south of the town of Elkmont, Alabama. Confederate soldiers regarded this trestle as a prime location to interrupt the transfer of Union supplies. The fort was a 300-foot-square and 72-foot-high earthen redoubt embankment fortified with two wooden blockhouses. The small fort was protected by rifle pits, steep ravines and an open clearing to the south. If anyone fired on the fort, the enemy would surely be noticed and exposed. But the fort had one fatal flaw: it was constructed in a valley below adjacent hills.

On September 24, 1864, the fortification, two blockhouses and a force of Union patrol soldiers defended the trestle in the afternoon and into the night against some Confederate scouts. The Union forces had retreated within the fort while exchanging gunfire throughout the night. Because the fortification had been built below the summits of adjacent hills, it actually provided little defense against any attack.

By the morning of September 25, 1864, Forrest's troops had arrived and were in position and ready for battle. After a demand for surrender was refused by the Union commander Colonel Lathrop, Confederate forces began an artillery attack on the Union earthworks. About one thousand Union troops protecting the fort returned fire. The Union defenders had the advantage of a fortified position, but they had only two twelve-pound artillery pieces. Confederate artillery and sharpshooters were able to fire down on the Union troops with Forrest's eight cannon from the higher ground surrounding the fort. Forrest's artillery troops fired eight hundred rounds into the fort in a little more than two hours. Union troops tried to take cover in the fortification's buildings, but the artillery fire either destroyed the structures or set them on fire.

A brigade of Confederate troops charged across the open field in the valley. They were unable to breach the fort's defenses, and it resulted in the loss of a number of soldiers. The remaining soldiers took up positions in a ravine within one hundred yards of the fort and continued to pound the fort with firearms. The cannon fire and sharpshooters gave the Confederates the advantage and took out many Union soldiers. The battle lasted about five hours, and by noon, Forrest was demanding immediate and unconditional surrender. Colonel John B. Minnis surrendered the remaining eight hundred soldiers. There were about forty Confederate losses. Two hundred Union soldiers were killed, as was Colonel William Hopkins Lathrop. The Confederates took control of the fort and set the blockhouses and the trestle bridge on fire, burning them to the ground. Forrest captured seven hundred small arms, sixteen wagons, three hundred cavalry horses and equipment.

Many of the captured Union soldiers were sent to military prisons and eventually placed on the ill-fated SS *Sultana*, a Mississippi steamboat paddlewheel chartered by the government to carry some Union soldiers home at the end of the war. Most of the passengers were Union soldiers who had just been released from Confederate prison camps such as Cahawba and Andersonville. It was a 1,700-ton steamship designed to carry only 376 people, but it was overloaded with more than 2,500 passengers. Having survived the Civil War and inhuman conditions at prisoner of war camps, it was a cruel irony that the soldiers died just as their ordeal was about to end.

The *Sultana* tragically exploded on the Mississippi River near Memphis on April 27, 1865, due to improper repairs of its boilers. There were no lifeboats or life jackets. This became the worst shipwreck in American

history with the estimated loss of more than 1,800 passengers, surpassing the famous RMS *Titanic* disaster. Many of the Union men on the *Sultana* were captured at Fort Henderson in Athens or the fort at Sulphur Creek Trestle in Elkmont during the Battle of Athens in 1864.

The Sixteen Ghosts of the Donnell House

Everyone who lives in Alabama has most likely heard the tales of the ghosts at the historic Donnell House in Athens, Alabama. There have already been many stories written about the activity at the home. However, most people have never heard historic Donnell House stories like this before. There have been several new developments in the spirit activity of the home.

The antebellum 250-acre estate was owned by Reverend James Donnell. The construction of the home, which was built by Alexander Hamilton, was finished in 1851. It had many outbuildings, such as an outdoor kitchen and privy, a smokehouse, a weaving house, a carriage house, wash houses, a blacksmith shop, gardens and more. The hillside plantation home's driveway connected to the stage road that crossed through Athens.

Reverend Robert Donnell met Ann Eliza Smith, daughter of Revolutionary colonel James Webb Smith, in Tennessee. In 1818, Donnell and Smith were married. She had five children within the ten years of their marriage, leaving only one of the five born, James Webb Smith, to live out his life to maturity. Several years later, after the death of his first wife, Robert Donnell married Clarissa Lindley, daughter of the founder and first president of the University of Ohio in 1834. As 1855 rolled around, Donnell's son came to live at the home with his wife and family, which then consisted of about twelve children. Reverend Donnell died in the home in May 1855.

The Donnell House, although not directly on the battlefield, was the site of Civil War activity during the Sack of Athens. The home served as the headquarters for Union colonel Ivan Turchin and Union troops during the events at Athens. Colonel Turchin quartered his soldiers on the Donnell property. Many soldiers camped on its lawn during the Civil War. Unfortunately, in 1869, the Donnell family lost the house to bankruptcy due to poor economic conditions and some uncertain financial decisions as a result of the war.

Reverend Robert Donnell's son was a major in the Confederate army and would have been there, perhaps relaxing on the lawn with some of his

friends, before the home was taken over by Colonel Turchin. One of the slaves on the plantation went with Major James Webb Donnell when he went to fight in the war. Strange as it seems, the slave stayed with him throughout the war, helping to cook for Major Donnell and with other things.

Because of Reverend Donnell's religious beliefs, he did not particularly believe in the keeping of slaves; however, he had acquired them through his marriage. Because he was a kind man, he chose to not release them; at that time, if a slave was released and freed, he or she was forced to leave the state. Reverend Donnell did not want to see the slaves separated from their families. If Donnell had released them, they would have had to leave their families behind and never see them again. So, in the best interest of the slaves and their families, he chose to keep them safe on his property, but it is said that he never treated them as slaves; he treated them as friends. Although they did help around the home with the work that needed to be done, because the plantation was huge and needed many hands to run it, Reverend Donnell felt like they were more a part of his family, and he took very good care of them.

The spiritual life of all those around the Reverend Donnell was very important. He would often have Bible study for his family and the workers of the plantation. He had one slave by the name of Fortune who was like a best friend to Reverend Donnell. It is said that they were always together at the home.

The house is supposedly haunted by several spirits, including the spirit of Nannie Donnell, grandaughter of Reverend Donnell. In 1862, Union troops occupied the home during the Civil War while Nannie lived there, and at the age of sixteen, Nannie died from scarlet fever. Many tourists who visit the home do not like to go into Nannie's room where she died. They feel a sense of sorrow and sadness that seems to be a result from Nannie's passing. A local legend states that the Union soldiers adored sweet Nannie, and when she was sick from the scarlet fever, some of the Union soldiers sang underneath her window. They say that folks who go to the home can often hear the toys upstairs being rearranged in the room where she died. At least one tourist of the home claims that when she was in the room, she felt an overwhelming heat, believed to be a symptom of the fever that Nannie would have felt when she was dying.

There have been several accounts suggesting that Reverend Donnell still remains there. Apparitions of the reverend and his mother, Mary Bell Donnell, have been seen in the antebellum home by many tourists. There is a sense that the family spiritually returned to the peaceful home after the

The historic Donnell House in Athens, Alabama, which became the headquarters during the "Sack of Athens" for Union general John Basin Turchin (born Ivan Vasilovitch Turchininoff). Witnesses claim that the house is haunted by many ghosts. *Courtesy of the Library of Congress.*

Civil War crisis ended. A visitor once said that she saw Reverend Donnell having a Bible study while his mother was making biscuits for the guests.

Other tourists have claimed that their personal experiences have included seeing both Confederate and Union soldiers on the property. Apparitions of two Union soldiers were seen on the lawn fighting with a Confederate soldier. The voices of the men have been heard shouting, yelling and scuffling. Other apparitions seen at the home have included several Confederate soldiers just kicking back, relaxing, laughing and lounging around on the lawn as if they were just enjoying the sunshine radiating down on them. Are these experiences possibly residual energy from historical events that took place at the location during different periods? Since Reverend Donnell's son was a major in the Confederate army, it is very plausible to say that he could have been there, relaxing on the lawn with some of his friends. Since the home was used as a headquarter base, could that explain the Union and Confederate soldiers fighting one another? It is probable that there could

have been fighting at the home between Confederate and Union troops before, during or even after the Sack of Athens. We must remember that Athens endured many battles during the Civil War.

Apparitions of a slave and his family have been seen on the property as well. A tourist claimed to see a slave wearing a white cotton apron walking around the home. This would not be unlikely, as the men often worked with meat and hogs in the smokehouse. The food was often too heavy for the woman to lift. The Donnell plantation was home to the slave named Fortune, and he was very happy there. A visitor to the location said that the apparition of the unknown slave was just walking on the property near the house but would not look up to make eye contact. This was a common activity for slaves as they were not allowed to address white folks or make eye contact.

The slave just kept walking back and forth in front of the tourist. It seemed almost as if he wanted to be noticed, but as he did this, he kept his head in a downward position the whole time. At times, the visitor noticed that he would glance with his eyes to the side, with head down, to see if the tourist was watching him walk by. He had about four slave children running around him, playing and having fun, as well as a female slave who had a white wrap around her head. All of them had white cotton clothing on with the exception of another child, a white child, who could possibly have been Reverend Donnell's granddaughter. The unknown slave also appeared to be wearing something under his apron that looked like a dark-colored denim or corduroy fabric. Because the slaves were friends with the family, it was common for all the children to play together. There was no segregation at the home. Was this a remnant of that activity that happened so long ago? Why was the slave acting as if he wanted to interact with the tourist? Was it just that he really couldn't communicate because he was trained that slaves were not supposed to? Did he not realize that slavery is over? Could this have been the loyal slave who went with Major James Webb Donnell when he went off to fight for the Confederacy? Could this have been Fortune?

Apparitions of other family members at the home have also been seen. Maria Jones Donnell, dressed in a long, full white dress, has been seen tending to the children of the home from the front balcony. She was a very attractive woman, gentle in nature, although she was also as authoritative and reserved as a mother figure would be. Her hair was light brown and placed up in a bun. She seemed to be a very proper and influential woman. She was also very conservative, and the collar of her dress went up to the base of her chin. She appeared to be an intelligent spirit because she was

aware of the tourist's presence at the home. She looked directly at her but then seemed to just return to what she was doing.

Since Major Donnell had several children, it wouldn't be a surprise to learn that yet another apparition has been seen: a seven-year-old girl, who skipped up and down the concrete walkway to the front of the home. She appeared to be very happy and playful. This little girl was most likely one of General James Webb Donnell's daughters. He had about twelve children who resided in the home when he lived there. Many of them died at the location. The tourist was in a state of shock, and the little girl eventually approached the tourist and asked for her Mommy. She told her that her name was Emily. Since the little girl was openly interacting with the tourist, paranormal researchers would consider this little girl an intelligent spirit. The visitor said that Emily's eyes told the story that she seemed frightened and confused. Was this little girl's scared demeanor due to her memory of the sudden infiltration of Union soldiers who took over her home in 1862, or was this because there were tourists on the property whom she didn't know?

Images of a man have also been seen in the front window of the home, peeking out the window when the building was completely empty and locked up. A local paranormal team performed research at the location, and members' audio evidence revealed that there are two families of spirits that reside at the plantation home, as well as Civil War soldiers.

James Webb Smith Donnell, husband of Maria Jones Donnell, has been seen by several visitors to the location. One day, it was said that he came up right behind a tourist, and as she turned around, she said that she unexpectedly saw him standing right there behind her. She was filled with fear, shock and terror. She said that he was dressed in a dark-blue suit, looked upset and was within arm's distance. Major Donnell was the son of the reverend, but surprisingly, he didn't affiliate with any religion until just before his death. According to Jacque Reeves, curator of the historic home, an intuitive who had previously toured the location claimed that Major Donnell felt anxious due to losing everything he had as a result of the war. Was this why Mr. Donnell seemed so upset?

Local residents have stated that on foggy nights, they will sometimes see Colonel Turchin and his men riding their horses through the city of Athens, seeking forgiveness for their wicked ways. Overall, it seems as if the spirits at the historic Donnell House want everyone to know that this is still their property.

CIVIL WAR GHOSTS AT THE TRESTLE

Several town residents in Elkmont, Alabama, frequent the walking trail where the Battle of Sulphur Creek took place. The trestle now holds a town walking trail lined with historical markers and information about the battle. According to many of the locals, there have been several odd experiences, sightings of unusual things and experiences that have taken place at the location. The fight over the Sulphur Creek Trestle railroad bridge resulted in about forty Confederate losses and two hundred Union soldier casualties. Colonel William Hopkins Lathrop was also killed in the battle.

On a Saturday evening, close to the anniversary of the Battle of Sulphur Creek, a local town couple was just taking a stroll down the walking trail. They stopped to look at the historical marker on the path that explains where the Union and Confederate forces battled on the landscape. At that moment, they said they both felt a very strong surge of electrical energy that gave them a tingling sensation all over their body, and then they saw a flash of light. There were no power outlets on the trail. They said that they could never come up with a reasonable explanation for this odd experience.

Another story comes from a local resident who was walking the trail one evening. He said that he was not too far from where the fort area was. He claims that he began to feel a burning sensation in his lower back, and a sudden headache came upon him. At that moment, he heard a whisper but could not see anyone around him. Feeling confused, he then decided that he was going to head back toward the beginning of the trail. When he turned to leave, he said he felt a forceful tug on his pant leg. He thought it was a cat going by his leg, so he looked down, but there was nothing there. At that point, he then experienced an excruciating pain in his buttock. It almost felt as if he were shot by a bullet. These strange events made him leave the location immediately, and he swears by the fact that he believes there are ghosts at Sulphur Creek. Was the pant tug of his leg actually a wounded soldier seeking medical help?

A group of kids was out on the trail really late one spring night. The kids were just hanging around having some fun. They said that they felt the temperature severely drop, and it got really cold really fast. One of the kids began to cry for no reason. She said that she didn't know why this was happening. They huddled together for a brief moment due to the chill because they weren't wearing spring jackets. They said it was freezing. At that moment, they heard some muffling and then a whisper. They said it sounded like someone had said, "Shoot to fire," or, "Shoot the thigh." They

were not in agreement as to what was really said, but they all heard it. They began to get tingling sensations all over their body, like an electrical surge, and then at that moment, a Union soldier appeared to them out of nowhere. As soon as he appeared, he disappeared. They all were freaked out and ran as fast as they could to get out of there. They have only told their story to a handful of people because they said that they thought no one would believe them. Did all these folks really experience supernatural events? Are there truly some unsettled ghosts still lying on the battlefield at Sulphur Creek, asking or begging for help?

THE CONFEDERATE GHOST OF ASU

At Athens State University, one of the most popular ghost stories is that of opera singer Abigail Burns, who is said to still haunt McCandless Hall. In our research, we found that there is no mention of an Abigail Burns in the dedication ceremony, her death records have never been recovered and no obituary has been found. However, regardless of the lack of substantial proof for this local legend, many of the students feel that she did perform there at some point, and you can frequently smell roses because of her presence. It is said that she was clutching a bouquet of roses she received from her opera performance when she died in a tragic horse and buggy wreck.

But Abigail is not the only one who still haunts the university. You have mostly likely heard or read other stories about some of the local legends, including a female student who was killed when her hair caught fire from the candles that she and a friend were holding while trying to sneak out after curfew to meet some boys. During our interviews with some of the students, they say that her spirit is blamed for disembodied footsteps, lights turning off and on by themselves, cold spots and a phantom figure walking up and down the stairs. They also say that you can sometimes witness a candle floating about waist high in the halls, as if someone were walking with it. Books have also been known to fly off the shelves of their own accord in the old library.

The Athens State University campus houses a handful of haunted structures, including McCandless Hall, Founders Hall and even Browns Hall. Founders Hall has four main columns, named Matthew, Mark, Luke and John. Founders Hall was constructed between 1842 and 1845, but

Founders Hall at Athens State University in Athens, Alabama. Ths university is notoriously known for the haunting by opera performer Abigail Burns. Civil War soldiers have been reported to walk the campus grounds as well. *Courtesy of the Library of Congress.*

originally in 1822, there was just a small four-room house where an all-female academy had originally been founded, making it the oldest institution of higher learning in Alabama. The school eventually became a coed facility in the later years.

In 1862, during the height of the war, Colonel Turchin and his troops approached the all-female institution during the Sack of Athens. Madame Jane Hamilton Childs, the headmistress, who was from a prominent Virginia family, was authorized to oversee the academy during the Civil War, which is now the site of Athens State University. Union army Colonel John B. Turchin and his troops rode into Athens to remove the Confederate forces from the town as part of the Union's counterattack of Fort Henderson and the city. When they reached the campus, the colonel ordered his men to halt and rest their horses. At that point, Turchin was confronted by Madame Childs as she bravely met him at the door of Founders Hall.

Turchin demanded that the structure be evacuated so it could be burned to the ground. Childs didn't say a word, instead handing Turchin a letter that she had obtained through her Virginia connections that was signed by President Abraham Lincoln—it instructed that the school was to be saved at any cost. Turchin read the letter, saluted and rejoined his troops, ordering them to guard the campus during the entire siege of Athens. As Turchin

retreated, this event saved the institution from the vandalism and pillaging by his troops. Although they did not directly assault the school at that time, both Confederate and Union troops battled in and around the city near the school during much of the Civil War. During the march to Athens, as Nathan Bedford Forrest continued approaching Fort Henderson from the southwest, he sent Colonel C.R. Barteau and the Second Tennessee Cavalry north of the female seminary.

After a full day of interviewing local residents and students in the area, we found that there is much more going on at ASU than we originally anticipated. But of course, why wouldn't there be, with its extremely long history of events?

Among the legendary hauntings, during our interview process, we learned of a Confederate soldier that resides around the campus at Athens State University. Some believe his name is James. He is a young soldier who appears to be about twenty-one years old, and he is seen wearing his Confederate uniform. He just wants people to know that he is still there. He doesn't usually say very much and seems rather shy, but he makes sure that he is noticed by visitors or students of the campus. He has been seen near the fountain area of the campus just walking around as if he is patrolling the grass area near Brown Hall. He seems very benevolent and doesn't intend to harm anyone. He is believed to just be guarding his post, awaiting further orders.

There has also been a report that a Union lieutenant walks the grounds of ASU. They say that he just walks the perimeter of the school, never really bothering anyone. Could this ghostly soldier be one of the guards whom Turchin stationed there to protect the property? Is he still on patrol?

ADDITIONAL CIVIL WAR HAUNTED STORIES IN ALABAMA

Much of the state of Alabama had skirmishes and actions resulting in Confederate and Union casualties, such as the Moulton Action on May 29, 1864; the Madison Station Affair on May 17, 1864; the Guntersville Expedition on July 27–30, 1862; the Ladiga Skirmish on October 28, 1864; and many more. It is with great sadness that we could not research and investigate all the locations that could be potential haunted sites, as we would have never finished this book. However, we were able to round up a few more stories from local residents of battles, action and other ghostly tales that took place in Alabama during the Civil War.

THE GENERAL STILL GIVING ORDERS

Historic Woodville, Alabama, and the surrounding area formed the site of many Civil War skirmishes and considerable guerrilla warfare during the American Civil War. Union troops occupied Woodville between 1862 and 1864. On January 23, 1864, at about 9:00 p.m., about sixty Confederate soldiers invaded an animal corral about three miles outside Woodville. The Confederates came through the summit on the mountains, avoiding roadways to remain undetected. The descent on the corral drove off about ninety of the animals; however, they managed to seize about seventeen teamsters. About four Confederate soldiers stayed at the corral, preventing any citizens from alarming Union brigadier

general Charles R. Woods. The Confederate quartermaster had ordered his troops to pick up the animals. Brigadier General Woods ordered troops out in pursuit with about sixty mounted artillerymen and twenty mounted infantry.

By the time General Woods was notified, the effort to recover the animals was pointless. Too much time had passed to successfully retrieve the animals or capture any soldiers. On January 30, 1864, Brigadier General Woods sent out a party of fifty men through the country about three miles out between Paint Rock and Flint River. The commanding lieutenant returned to Woodvile reporting that about twenty Confederates had skirmished with the Union troops and retreated near Cobb's Mill. There were no casualties. On March 30, 1864, Union brigadier general Peter J. Osterhaus learned that some of Confederate colonel Lemuel Green Mead's guerrillas were hovering about fourteen miles from Woodville. Mead's men were of the Company C of the Twenty-sixth Alabama Infantry Regiment and served with distinction at the Battle of Shiloh in April 1862. General Osterhaus sent out an expedition, and they returned having killed one lieutenant, one first sergeant and three soldiers.

Many of the Confederate guerrillas in northern Alabama were detached cavalry units that were used to great advantage in protecting the homefront as opposed to serving in the main army. The primary mission of the Confederate guerrillas was to attempt to keep the Confederate order intact. They assisted the war effort in their own backyards by hunting down and arresting Unionists, sympathizers and deserters. In addition, they terrorized Unionists by destroying their property and threatening their families. Confederate guerrillas were made up of four types of warriors. Some of the men were under Confederate supervision, being either detached cavalry or enlisted men fighting close to home. The other units were not under Confederate control and either fought disguised as noncombatants or were simply outlaws looking for bloodletting opportunities. They were interested in just helping the Southern cause.

Moses Maples, who settled in Woodville in 1827, was a Union sympathizer and opposed secession. He and his wife, Catherine, built Union Church in Woodville and subsequently added a cemetery to the land. Because of his loyalty to the Union, he was robbed and seriously wounded by Confederate soldiers and was even threatened to be murdered in his bed. In order to save his life, he wrote a letter to declare his loyalty to the South; however, he still endured much devastation from Confederates and bushwackers. Unfortunately, even though Mr. Maples was loyal to the Union, the Federal troops also treated him poorly. General Sherman's infantry and cavalry armies camped on Moses's land and destroyed much of what he had. The Union troops needed wood for fire and shelter and crops and livestock for

food, and they also took his horses and more. The Union troops destroyed the church, leaving only the graveyard.

At this graveyard, named Woodville Union Cemetery, many CSA and Union soldiers are buried, and the Civil War still seems to be going on. Could there possibly be unsettled soldiers still rolling about in their graves because of the fighting between the states? Residents of Woodville say that local legend claims that if you go there late at night, you can hear the screams of all the buried Confederate and Union soldiers who fought in and around Woodville, Alabama. Are these soldiers crying out for acknowledgement? Are the soldiers of all the unmarked graves asking for someone to recognize their identities? Are they trying to get our attention so that people remember what happened in Woodville? Or is it just possible that these are the screams from the battles? In our research travels, we noted that there did not seem to be any memorial historical plaques or markers at Union Cemetery or in Woodville regarding the acknowledgement of any of the unknown soldiers or the Civil War. There was, however, a historical marker for the site of the old church that had been burned down. Do these ghosts want us to remember them and their service to our country?

Another local story that has been told relates that when at the cemetery, people have seen Confederate soldiers among the trees, crouched down in hiding with guns, lining the right side of the cemetery as if they were attempting to snipe or ambush the Union troops. Confederate soldiers were good game

Alleged unidentified Union and Confederate soldier graves at Woodville Union Cemetery. There are 441 unmarked graves, 31 adult rock mounds and 14 child rock mounds in the cemetery. This is the site where many people hear cries of a battle.

and fowl hunters, so they would have been proficient in hiding to keep cover. Other claims from local visitors to the cemetery have been that they have seen Confederate soldiers dressed in gray uniforms with red accents fighting Union soldiers with their arms and hands, almost as if they were wrestling for their life. There were no guns involved—it was just hand-to-hand combat. Was this a possible guerrilla raid? Is this an event replaying over and over again?

A few local residents said that they were there late one night just to watch the stars and enjoy the moonlit sky. The landscape is so smooth that the grass was just enjoyable to lie on because you could see the whole brightly lit sky. They were sitting under a tree, just talking and enjoying the mood. The night was so quiet that all they could hear were crickets chirping. They said that all of a sudden, they heard a sound that resembled cannon fire, but they just dismissed it as their imagination. Out in the distance, they saw weird, bright, ivory-colored and circular lights hovering above the ground. They noted that there was nothing in the area that could have caused a reflection. They claimed that some very cold breezes blew in, and at about 12:30 a.m., they heard the sound of rushing water, which they had not heard up to that point. The sky was so bright from the moon and stars. Within just a few minutes, they thought they saw a few figures on horses in the distance near the road. Bewildered, they wondered who would be out there on horses so late at night.

At that moment, a Union soldier mounted on a horse approached the visitors very casually, almost as if he had ownership of the land there. He had several other soldiers behind him, spread apart in a zigzag position. They said that he looked transparent to some extent, but he was a full-body apparition. The other soldiers were as well. They said that he resembled a Union general based on his uniform and majestic demeanor. He ordered his troops behind him to stop with a hand wave. He then yelled, "Halt." They said he appeared very authoritative and told them that they were now prisoners of war but that he meant no harm. He wanted to know why everyone was just sitting around. Didn't they know they were in town?

The soldiers seemed to think the visitors were Southern folks or Confederate soldiers. They said it felt almost like the Union troops had seized the town already and were just casually patrolling the area to make sure nothing was out of the ordinary. He told the cemetery visitors that they were now considered captive and that they needed to get up. At that moment, he disappeared completely, never to be seen again that night. The whole scene lasted about five minutes from beginning to end. They were officially freaked out after this event and became believers in ghosts. Is this Union general still giving orders on the other side? Does he feel that he has authority to capture civilians? Was he reliving a

scene while residing in a different dimension, where time may be continually repeating? Did these visitors experience a warp in time?

SWEETWATER MANSION

In 1828, construction on Sweetwater Mansion had begun by John Brahan, who owned the four thousand acres of land that the Indians called Sweetwater due to the freshwater creeks nearby. Six years later, ownership of the unfinished home was transferred to John's son, Major Robert Brahan, because John Brahan had passed away. Major Brahan chose not to take up residence there and gave the property to his sister, Jane, and her husband, Robert Patton. Robert Patton would later become the governor of Alabama, serving the state from 1865 to 1867. In 1835, the two-story home was finished, and Robert Patton, along with his wife and family, moved into the residence. They had nine children, but only seven lived to adulthood. Two of the boys were lost in battle in the Confederate army. Sergeant Robert Patton was one of the two Patton boys in the Confederate army. He died in the Battle of Selma. Billy Patton died on the battlefield during the Battle of Shiloh.

Sergeant Robert Patton suggested that Confederate brigadier general Gideon Johnson Pillow use Sweetwater for his headquarters. Johnson set up headquarters, and his men set up an encampment around the property. On October 30, 1864, Confederate forces crossed the river at two places to remove the Union forces from the town. Lieutenant General Nathan Bedford Forrest arrived two weeks later with troops of three thousand cavalrymen. They were ready to defend the city against the arrival of General John Bell Hood's Army of Tennessee on November 15 with about twenty-seven thousand infantrymen and two thousand cavalrymen. General Hood set up his headquarters on the north end of the city. Sweetwater and the nearby Price and McCorstin Plantations were used by both Union and Confederate soldiers at various times for most of the war years. Fortifications were made at Sweetwater but were eventually eradicated years after the war ended.

When the Confederate officers were off-duty, they attended festive and gala events, as well as a number of dances, including a military ball at Sweetwater. It was on the night of this military ball that General Pillow fell into the basin of the fountain in the center of the wide front walk. It was rumored by other soldiers that the general had broken his arm in the fall. Over the years, a former slave at Sweetwater, Uncle Mose, loved to tell his

story of the ball, with his humorous account of the general who fell into the water fountain, exclaiming that the soldier was drunk.

During the war, one of Union general Sherman's divisions also set up an encampment at Sweetwater. As soon as the camp was set up, the soldiers began roaming the plantation in search of rations and other supplies. All the meat and fowl of the plantation was taken by the soldiers, and all of the horses and cows were confiscated for the use of Sherman's march to Chattanooga. The wine cellar was cleaned out, and pickles, beans, potatoes and corn were carried away as the home was raided over and over again. The home was also used as a hospital. Many soldiers who suffered from smallpox were quarantined in the slave cabins on the property to stop the spread of disease. The troops resorted to burning two of the cabins on the property with the soldiers in them.

Edmund Patton, a heroic slave at the plantation, waited up one night to take patrol watch from the front steps of the mansion. It wasn't long before he heard the invading soldiers. Edmund quickly alerted Robert Patton that soldiers were coming. The soldiers forcefully entered the home by battering down the side door and rushed toward the stairwell where the young girls were upstairs sleeping. Edmund threw his arms across their path and told them that they would not go up there unless it was over his body. The soldiers

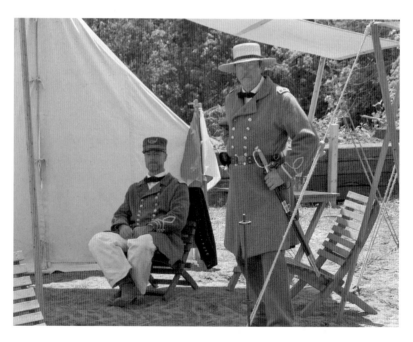

Confederate army encampment scene at the Siege of Bridgeport Reenactment.

terrorized the family by ransacking the rooms of the home, consuming their food and demanding valuables at gunpoint.

Mrs. Patton broke away and ran to her room frightened. She was chased by a Union soldier, and Mrs. Patton let out a scream, causing the family to run to her aid. Upon entering the room and seeing the soldier on his knees over his wife, Mr. Patton threatened the soldier's life if he touched her. Due to the ensuing danger of the situation, and while the soldier was attempting to search her, Mrs. Patton dropped her purse contained in her sleeve, which contained valuable and sentimental items, including three diamond studs that had belonged to her son, Captain Billy Patton, who had died at the Battle of Shiloh.

The siege lasted until after 3:00 a.m., and the soldiers took everything they could. The family was instructed to shut off all lighting of the home. The soldiers threatened to burn the house down if the family alarmed anyone. They say that General Sherman most likely did not know about this violent incident at Sweetwater. But the town would never forget. The family remembered the heroism of old Edmund and gave him a farm and a comfortable house, where he lived the remaining years of his life. He was buried in the ancient family cemetery on the plantation with a lovely marker on his grave. Sweetwater also once served as a Civil War hospital, and they allegedly buried the bodies right below the front porch.

The haunted stories about the ghosts at Sweetwater are numerous, as told to us by local resident and paranormal enthusiast Robert Simone. Undoubtedly, they have circulated all over the state. However, many of the following Sweetwater Mansion stories have never been told before.

Since Patton's two male children were in the Civil War, there have been many reports of apparitions of a Confederate soldier believed to be the governor's son Billy Patton. Has he returned home from battle? Is it at Sweetwater that he remembers the best days of his life and so refuses to leave? Is he trying to protect his mother or the valuable diamonds that were stolen by Union soldiers on the night of the horrific attack?

The stories range from Billy's ghostly presence to many others spirits that have resided in the home as well. There are claims that music is heard playing on occasion on the old piano that resides in the parlor, where guests were entertained by the former governor in the late 1800s. One of the previous resident caretakers of the building recalled that on the second story of the home, a light was turned on and faucets would turn on of their own accord, all while she was trying to sleep at night. She told stories of the piano playing all night and hearing noises that made it sound like a party was going on in the home.

One interesting story the caretaker told was about the funeral that was supposedly held in the foyer. She reported that she saw a casket laid out in

one of the downstairs rooms, with the corpse of a Confederate soldier lying inside the casket. She stated that the Confederate soldier had a hole in his head. She later learned about the death of one of Governor Patton's sons. At that moment, she realized that what she had most likely seen was the body of Billy Patton. The governor's son was shot (in the head) and killed at Shiloh. His funeral was conducted in the house. The caretaker learned that where she saw the casket was where the funeral was actually held. The sconces on the wall in this room would occasionally light up. Other visitors to the home have witnessed the light phenomenon firsthand as well.

One evening, some typically adventurous teenagers decided to take photos of both the interior and exterior of the home. Because it was all boarded up, they could only peer inside the windows. As they were looking inside the windows of the home while trying to take photos, everyone was both still and quiet. Then, all of a sudden, they heard a huge bang come from the inside of the house. They said that the noise sounded like someone banging on the wall or stomping their foot on the floor extremely hard. Whatever it was, they said it was really loud and that it definitely came from the inside of the home when nobody was in it. Astonished, they just looked at one another, and then one of the girls said, "Please tell me I'm not the only one that just heard that!" The teens suddenly took off down the driveway to get out of there. We can only assume that after that incident, they believe the stories about Sweetwater's haunting or unusual phenomena.

The basement once served as a Civil War hospital and a jail, according to *Paranormal State* on the Syfy Channel. The team was invited to perform an investigation at Sweetwater due to the amount of activity the home holds. The team claims that during the taping of the show, investigators reported seeing a door move and the sensation of a heavy feeling on the second floor. They also claim to have heard sounds of footsteps and the sound of a board sliding across the floor. The sounds of something or someone falling were noted as well. The cast members said that they plan to return to the mansion for another investigation.

Robert Simone, caretaker of the plantation home, claimed that he has had some personal encounters of his own. He said that he has fallen down the stairs after being nudged from behind, discovered chairs moving on their own and had a section of the ceiling flung past him. Two ghostly children appeared in a photograph that he took exactly at that moment. He also said that doors have slammed and become "locked," even though there are no locks on them. There have been other reports that a Civil War soldier has been seen sitting on a log holding a cannon ramrod. Many photographic light anomalies and figures of apparitions have been captured in the home

Sweetwater Mansion in Florence, Alabama. The plantation was the site of significant Civil War action. The home and property still resonate with ghostly activity. *Courtesy of the Library of Congress.*

by both camera and video recorder. Candles and picture frames have been knocked off fireplace mantels, as if someone had run their whole arm across the mantel, knocking off the items with one sweep.

Shadowy figures, audible whispers, children laughing, objects being moved or thrown and an apparition of a woman wearing nineteenth-century clothing have also been reported throughout the house. One visitor noted that a young woman was wearing a beautiful Civil War–era yellow ball gown with white trimming and lace. Full-body apparitions of slaves have also been reported on the property. The slaves have been seen walking inside the home, outside the home and in the basement area as well. A visitor to the location reported taking a tour through the house. She was in the basement of the home, and as she walked into the second room of the basement, much to her amazement, she saw a slave woman cooking at a fireplace and then carry a cast-iron fireplace cooking pot to a wooden table. She said that she had a white dress on with a white wrap around her head, and her hair was put up. She was about forty years old. It appeared as if the slave was not aware that the woman was in the doorway watching her. It appeared as if the slave woman was just tending to her business and doing her regular chores. As soon as the visitor saw this, the apparition disappeared.

There have been other reports that a slave has been seen carrying a deceased full-term white baby wrapped in white swaddling coming from the

bathroom on the first floor of the home. It is said that Mrs. Patton had nine children, but only seven lived to maturity. Is this activity a possible replay of a tragic event that took place for the Patton family? Did she lose one of her babies in childbirth? Is this energy from such a tragic event still embedded in the walls of the home? Other visitors of the home claim that they have seen the apparition of a ghostly woman in a bloody bathroom tub upstairs on the second floor. It appears as if the woman had just given birth. Was this woman Mrs. Patton delivering one of her children at Sweetwater Plantation?

A recent visitor at the home said that she felt someone come up right up behind her and breathe on her neck. Not expecting this encounter, she seemed very scared and distraught. She composed herself and finished the tour of the home. There were also other claims that people have felt extreme chills and electrical sensations, heard whispers in their ears, experienced nausea and seen images of people appearing right in front of them. Shadow people have been witnessed on the second floor of the home. There also seems to be a heavy energy pressing on the chest of visitors while touring the second floor, making them cough at times. Did this spirit die of tuberculosis, pneumonia or a lung condition? Where they shot in the chest? Many people claim that there is no doubt that you can feel a difference in the air quality between the first and second floor. On the second floor, the air just feels thicker and heavier, almost making it difficult to breathe.

The Alabama Paranormal Association team investigated all of the locations during the making of this book, with the primary goal to either validate or dismiss the many claims reported by so many people. The positive scientific evidence that was recovered speaks for itself at many of the locations. Many of the claims were validated, and the locations are truly considered "haunted" in our opinion. But as always, we leave that decision up to you as to what you want to believe. We can only share what we have found in our research.

We have found through the years that most people are afraid of what they don't know. If someone is uneducated about something, they automatically see it as something to fear. As humans, we are just conditioned to fear the unknown. Not everything that goes bump in the night is something to be afraid of. What if it's just a squirrel in your attic? The same goes with ghosts. Not all ghosts are bad and intend to do the living harm. Many just have a story to tell or a message to deliver, such as the ghost that wanted his wife to have his wedding ring. With that in mind, we challenge you to find your own answers. You may just find out that all the things you thought you knew, or what you thought you needed to be afraid of, are nothing more than your own fear.

BIBLIOGRAPHY

Alabama Historical Commission. *Cahawba's Civil War Sites.* Self-guiding tour publication. Montgomery, Alabama, n.d. Available at the Alabama Historical Commission.

———. Self-guided tour brochure of Fort Morgan, National Historic Landmark. Montgomery, Alabama, n.d. Available at the Alabama Historical Commission.

Alabama's Front Porches: The Ghosts of Alabama's Black Belt. Tourism brochure. Available at Old Cahawba, Orrville, Alabama.

The American Catholic. "April 21, 1863: Streight's Mule Raid Begins." http://the-american-catholic.com/2013/04/21/april-21-1863-streights-mule-raid-begins.

The American Civil War Homepage. http://www.civilwarhome.com/casualties.htm.

Ballam, Ed. "Alabama Man Interprets Forrest-Streight Trail in Cullman County." *Civil War News.* http://www.civilwarnews.com/archive/articles/forrest_streight.htm.

The Battle of Selma. "Memories by W.O. Perry." http://www.battleofselma.com/index.php?option=com_content&view=category&layout=blog&id=3&Itemid=81.

The Blue and Gray Trail. "The Civil War in Alabama." http://blueandgraytrail.com/state/Alabama.

Cherokee County Herald. "Yankees, [Rebels] Meet Again at Sulphur Creek." June 14, 1989. GoogleNews. http://www.news.google.com/newspapers?

nid=354&dat=19890614&id=DB8uAAAAIBAJ&sjid=aT4DAAAAIBAJ
&pg=6331,1743421.

Chickamauga Indian Confederacy. "Chickamauga Timeline: Massacre of Fort Mims." http://www.chickamauga-cherokee.com/fortmims.html.

Civil War Album. "Fort Blakely, Alabama." http://www.civilwaralbum. com/misc/fortblakely1.htm.

Civil War Trail: Battle for Mobile Bay. "Strategic Value of Mobile Bay." http://www.battleofmobilebay.com/civil-war-times/strategic-value.aspx.

Civil War Trust. "The Battle of Mobile Bay." http://www.civilwar.org/ battlefields/mobile-bay.html.

Cullman County, Alabama. Crooked Creek Civil War Museum. http:// www.co.cullman.al.us/Press/crooked_creek_museum_opening.html.

———. "Cullman County History." http://www.co.cullman.al.us/history2.htm.

Decatur, Alabama. "The Battle for Decatur." http://decaturcvb.org/ activities/item/the-battle-for-decatur.

———. "Decatur Walking Tour." http://decaturcvb.org/images/ brochures/Decatur_Walking_Tour.pdf.

Delinski, Bernie. "Sweetwater Mansion Site of Paranormal Activity Hunters." *Times Daily.* http://www.timesdaily.com/archives/article_ f2262411-b43c-5bab-968f-40c953f0496d.html.

Donnell House. "Pleasant Hill: Home of Rev. Robert Donnell (1784–1855)." http://www.donnellhouse.org/html/history.html.

Eddy, D.D.T.M. *The Patriotism of Illinois: A Record of the Civil and Military History of the State in the War for the Union, with a History of the Campaigns....* N.p.: Ulan Press, 2012.

Ehle, John. *Trail of Tears: The Rise and Fall of the Cherokee Nation.* N.p.: Anchor Books Editions, 1989.

Encyclopedia of Alabama. "Battle of Decatur." http://www. encyclopediaofalabama.org/face/Article.jsp?id=h-2580.

———. "Battle of Selma." http://www.encyclopediaofalabama.org/face/ Article.jsp?id=h-3442.

———. "Civil War in Alabama." http://www.encyclopediaofalabama.org/ face/Article.jsp?id=h-1429.

———. "Fort Mims Battle and Massacre." http://www. encyclopediaofalabama.org/face/Article.jsp?id=h-1121.

———. "Forts Morgan and Gaines." http://www.encyclopediaofalabama. org/face/Article.jsp?id=h-1800.

———. "Lost Cause Ideology." http://www.encyclopediaofalabama.org/ face/Article.jsp?id=h-1643.

———. "Sack of Athens." http://www.encyclopediaofalabama.org/face/Article.jsp?id=h-1819.

Explore Southern History. "The Battle of Fort Blakely—Spanish Fort, Alabama." http://www.exploresouthernhistory.com/blakely1.html.

———. "Castle Morgan Civil War Prison: Old Cahawba, Alabama." http://www.exploresouthernhistory.com/oldcahawbaprison.html.

———. "Fort Morgan State Historic Site—Gulf Shores, Alabama." http://www.exploresouthernhistory.com/fortmorgan.html.

Fact Monster. "The Sinking of the *Sultana*." http://www.factmonster.com/spot/sultana1.html.

Fort Blakely battlefield maps and information brochures, Fort Blakely, Alabama.

48th Ohio Veteran Volunteer Infantry. "The 48th OVVI at Fort Blakely, Alabama." http://www.48ovvi.org/oh48blk.html.

Foster, Gaines M. *Ghosts of the Confederacy: Defeat, the Lost Cause, and the Emergence of the New South.* New York: Oxford University Press, 1987.

Fulenwider, Dan. *Civil War: Stories of North Alabama and the South.* Cullman, AL: Blalock, 1998.

Gallagher, Gary M., and Alan T. Nolan, eds. *The Myth of the Lost Cause and Civil War History.* Bloomington: Indiana University Press, 2000.

Gardner, April W. *Wounded Spirits.* Ladson, SC: Vinspire Publishing, 2010.

Gray, Jacquelyn Procter. *When Spirits Walk: Ghost Stories of North Alabama and Beyond.* Bloomington, IN: Author House, 2006.

Halbert, Henry S., and Timothy H. Ball. *The Creek War of 1813 and 1814.* Edited by Frank L. Owsley Jr. Tuscaloosa: University of Alabama Press, 1995.

Haunted Houses. "Fort Gaines." http://www.hauntedhouses.com/states/al/fort_gaines.htm.

Heidler, David Stephen, and Jeanne T. Heidler. "Creek War." *Encyclopedia of the War of 1812.* Santa Barbara, CA: ABC-CLIO, 1997.

Historic Selma Pilgrimage. "Kenan's Mill." http://selmapilgrimage.com/?page_id=356.

Jones, James Pickett. *Yankee Blitzkrieg: Wilson's Raid through Alabama and Georgia.* Athens: University of Georgia Press, 1976.

Jones, Marilyn, and Amy Shell. *Historic Alabama: A Guide to Landmarks and Events.* N.p.: Alabama Tourism Department, 2008.

Keenan, Jerry. *Wilson's Cavalry Corps: Union Campaigns in the Western Theatre, October 1864 through Spring 1865.* Jefferson, NC: McFarland, 1998.

Limestone Chamber of Commerce, Athens, Alabama. "Self-Guided Driving Tour Featuring the Battles of Athens & Sulphur Creek

Trestle." http://tourathens.com/wp-content/uploads/2008/12/civil-war-trail-single-pages-Feb-20101.pdf.

Mahon, John K. *The War of 1812.* Gainesville: University of Florida Press, 1972.

Manning, W.N. "Founders Hall, 1934." Photograph for the Historic American Buildings Survey (HABS), courtesy of the Library of Congress, Prints & Photographs Division.

McClure, Guy. "Athens State Homecoming to Honor Legendary Madame Childs." Athens Plus. http://www.athensplus.com/ASU_MadameChilds2012.htm.

McKay, John. *Insiders' Guide to Civil War Sites in the Southern States.* N.p., 2000.

McMurry, Richard M. *John Bell Hood and the War for Southern Independence.* Lincoln: University of Nebraska Press, 1982.

National Park Service, Department of the Interior. "Decatur." http://www.nps.gov/hps/abpp/battles/al004.htm.

———. "Fort Blakely." http://www.nps.gov/hps/abpp/battles/al006.htm.

———. "Fort Morgan." http://www.nps.gov/resources/story.htm?id=246.

National Trust for Historic Preservation, State of Alabama Bureau of Tourism and Travel. History and tour guide brochure for Fort Gaines and Dauphin Island, Alabama, August 2012.

Owsley, Frank L., Jr. "The Fort Mims Massacre." *Alabama Review* 24, no. 3 (1971): 192–204.

———. *Struggle for the Gulf Borderlands: The Creek War and the Battle of New Orleans, 1812–1815.* Tuscaloosa: University of Alabama Press, 1981.

Penot, Jessica. *Haunted North Alabama.* Charleston, SC: The History Press, 2010.

Selma and Dallas County, Alabama. "Kenan's Mill." http://www.selmaalabama.com/82-demo/top-rated-hotels-in-france/81-interdum-metus.html.

Selma-Dallas County Historic Preservation Society. "Kenan's Mill Festival." http://historicselma.org/kenans-mill-festival.

Selma Times Journal. Battle of Selma brochure publication. April 25–28, 2013.

Smith, Adam. "Ghost Tales Have Integral Role in Southern Culture." *New Courier.* http://enewscourier.com/x1607579374/Ghost-tales-have-integral-role-in-Southern-culture.

Sons of Confederate Veterans. "Siege of Bridgeport, Alabama Reenactment." http://www.scv-nbforrest3.com/bridgeport.htm.

South Pittsburg Historic Preservation Society. "Bridgeport, Alabama." http://www.historicsouthpittsburgtn.org/Bridgeport2.html.

State of Alabama Historic Preservation Office. "Fort Morgan." http://www.preserveala.org/fortmorgan.aspx.

Sweetwater Mansion. http://sweetwatermansion.blogspot.com.

Sword, Wiley. *The Confederacy's Last Hurrah: Spring Hill, Franklin, and Nashville.* Lawrence: University Press of Kansas, 1992.

Symonds, Craig L. "Damn the Torpedoes! The Battle of Mobile Bay." Civil War Trust. http://www.civilwar.org/battlefields/mobilebay/mobile-bay-history-articles/damn-the-torpedoes-the.html.

Thrapp, Dan L. "Weatherford, William (Lamouchattee, Red Eagle)." *Encyclopedia of Frontier Biography, in Three Volumes.* Lincoln: University of Nebraska Press, 1991.

True West. "Massacre at Fort Mims." http://truewest.ning.com/forum/topics/massacre-at-fort-mims.

The War of the Rebellion: A Compilation of the Official Records of the Union and Confederate Armies. Series I, vol. 10, part 1. Washington, D.C.: Government Printing Office, 1880–1901.

Waselkov, Gregory A. "Archaeology of Old Mobile, 1702–1711." *Gulf Coast Historical Review* 6, no. 1 (Fall 1990). University of South Alabama. http://www.usouthal.edu/archaeology/writings/pdfs/archaeology-of-old-mobile-1702-1711.pdf.

———. *Conquering Spirit: Fort Mims and the Redstick War of 1813–1814.* Tuscaloosa: University of Alabama Press, 2006.

Wikipedia. "Alabama in the American Civil War." http://en.wikipedia.org/wiki/Alabama_in_the_American_Civil_War.

———. "Bridgeport, Alabama." http://en.wikipedia.org/wiki/Bridgeport,_Alabama.

———. "Fort Mims Massacre." http://en.wikipedia.org/wiki/Fort_Mims_massacre.

———. "Fort Morgan (Alabama)." http://en.wikipedia.org/wiki/Fort_Morgan_(Alabama).

———. "Muscogee." http://en.wikipedia.org/wiki/Muscogee_people.

———. "Sloop-of-war." http://en.wikipedia.org/wiki/Sloop-of-war.

———. "33rd Ohio Infantry." http://en.wikipedia.org/wiki/33rd_Ohio_Infantry.

Willett, Robert L., and Edward G. Longacre. *The Lightning Mule Brigade: Abel Streight's 1863 Raid into Alabama.* N.p.: BookSurge Publishing, 2008.

About the Author

Dale Langella was born in Providence, Rhode Island, but moved to the state of Alabama when she was twenty-seven years old. Dale earned a degree in applied science in technical studies in 1989 from the Community College of Rhode Island. She has more than twenty years of experience working in laboratories and hospitals as a registered medical technologist. She is also pursuing another degree in business administration at Athens State University in Alabama. Dale has experienced many strange encounters while working in the hospitals that have suggested to her that there is more to life than just the living.

She has always had a passion for history, but when she moved to the South, her passion transformed into an interest in battles in the state and of the Civil War. She realized that there was so much that she was missing out on regarding the real story about the battles, and she began collecting stories of firsthand accounts of paranormal activities. She never realized how much history the state had. She began her quest for more information regarding the stories, history, legends and family accounts of what really took place, mostly in the years between 1861 and 1865. Astonished by what she was learning, she made it a goal to tell the story from the perspective of families who were directly involved in the wars, as well as the impact the wars had

on their families. She often records interviews on digital recorder and then reviews them for publication. She brings a diverse range of experiences to her writings, having had many odd experiences herself as a seasoned paranormal investigator, intuitive and researcher.

Dale is the founder and lead investigator of the Alabama Paranormal Association, as well as the team's scientist. She is a natural-born medium and has been involved in paranormal research for almost fourteen years. She is "The Southern Medium." Her knowledge of scientific research helps tremendously when investigating the paranormal. She provides a logical and analytical approach combined with scientific and technical reasoning. She loves investigating the paranormal, as well as helping people, and decided to take that passion to people who love to hear stories about it. She has been published in poetry books and enjoys writing, researching and sharing the stories of the South. She loves spending time with her family, playing guitar, website design, classic and antique cars, scrapbooking and investigating scientific phenomena associated with paranormal research.